ST ALBANS
THROUGH TIME
Robert Bard

AMBERLEY PUBLISHING

Acknowledgements

I would like to thank the members of the St Albans and Hertfordshire Architectural and Archaeological Society (SAHAAS), particularly Donald Munro, President, and Gill Harvey for assisting me. David Thorold, Keeper of Archaeology, at the Verulamium Museum provided me with a number of the older images. I would also like to thank Tom Entwistle, a descendent of Sir Bertine, for providing me with the appropriate illustration (Entwistle was a knight who fought at St Albans during the Wars of the Roses and is buried in the nave of St Peter's Church) and Peter Burley of the Battlefield Trust for walking me around the Wars of the Roses sites in St Albans.

For my parents, Joan and Harvey

First published 2012

Amberley Publishing
The Hill, Stroud
Gloucestershire, GL5 4EP

www.amberley-books.com

Copyright © Robert Bard, 2012

The right of Robert Bard to be identified as the Author of this work has been asserted in accordance with the Copyrights, Designs and Patents Act 1988.

ISBN 978 1 4456 0726 9

British Library Cataloguing in Publication Data.
A catalogue record for this book is available from the British Library.

Typeset in 9.5pt on 12pt Celeste.
Typesetting by Amberley Publishing.
Printed in the UK.

Introduction

St Albans is a city which has developed rapidly since the arrival of the railway in the mid-nineteenth century, but has managed, unlike many modern cities, to retain much of its historic character. The ancient Roman ruins were very much recycled to build later structures, including parts of the Abbey and the Gatehouse. The small red bricks are easily spotted. The massive Beech Bottom Dyke probably constructed between AD 5 and 40 by the Catuvellauni was used in 1461 as a defence by the Earl of Warwick (Warwick the Kingmaker) at the Second Battle of St Albans.

A number of ancient writers left accounts of events in St Albans so that comparing the landmarks of the past with the modern is reasonably straightforward. The names of the primary streets and districts have largely retained their names for several hundred years. The Abbey, Cathedral, dominates the town, visible for many miles around. The Abbey Gateway is the only remaining part of the monastery, to which it was the gateway. It was built around 1360. During the Middle Ages, the Abbey and the townsfolk were constantly in conflict. The Gateway was besieged in 1381 during the Peasants' Revolt, one of the leaders of which, the radical priest John Ball, came from St Albans.

Nearly a century later, on 22 May 1455, St Albans hosted the opening conflict of the Wars of the Roses. This was at Key Field, now the site of a car park. It is interesting when walking along Market Place and St Peters Street to think that Henry VI raised the Royal Standard, a declaration of war, in the vicinity of what is now the Boots store in St Peters Street. It was also here that he was injured in the neck by an arrow. Four of the King's bodyguard were killed and the Royal Standard was abandoned. The Abbot John of Whethamstede observed and recorded the vicious fighting which took place a few hundred metres away around the Clock Tower and Market Place from a window of the gateway: 'Here you saw one fall with his brains dashed out, there another with a broken arm, a third with a cut throat, and a fourth with a pierced chest, and the whole street was full of dead corpses.'

It was where the estate agent Connells is situated that, in the same conflict, the Duke of Somerset was killed. A contemporary source describes his demise: 'York's men at once began to fight Somerset and his men, who were within the house and defended themselves valiantly. In the end, after the doors were broken down, Somerset saw he had no option but to come out with his men, as a result of which they were all surrounded by the Duke of York's men. After some were stricken down and the Duke of Somerset had killed four men by his own hand, so it is said, he was felled to the ground with an axe, and at once wounded in so many places that he died.'

By the nineteenth century the Abbey, notable for its magnificent architecture as well as thirteenth- and fourteenth-century wall paintings, was on the verge of ruin and collapse, but was 'saved' by a local beneficiary. As well as the Market Place and Abbey, another favourite of mine for comparing past and present is Holywell Hill, where, until 1827, once stood Holywell House at the bottom on the east side. It was formerly the home of Sarah, Duchess of Marlborough. She and the Duke of Marlborough occasionally resided here. Echoes of the house in the form of Holywell Lodge remain. As a major coaching route on Watling Street, as well as being a place of pilgrimage, the city was, and still is, blessed with numerous inns. At the top of Holywell Hill is the fifteenth-century White Hart; in 1792 a traveller commented that it was 'perhaps the best here', but the inn was 'unequalled in filth, inattention and charge'. It is supposedly haunted by the decapitated passenger on a coach who failed to duck when the coach passed under the arch when it entered the yard!

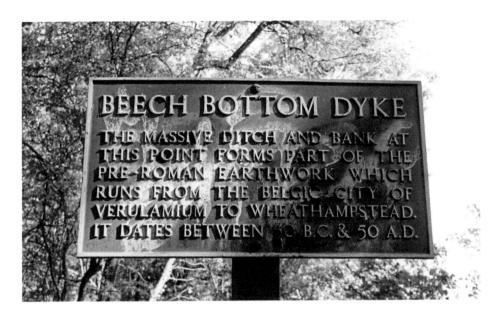

BEECH BOTTOM DYKE
THE MASSIVE DITCH AND BANK AT
THIS POINT FORMS PART OF THE
PRE-ROMAN EARTHWORK WHICH
RUNS FROM THE BELGIC CITY OF
VERULAMIUM TO WHEATHAMPSTEAD.
IT DATES BETWEEN 50 B.C. & 50 A.D.

Beech Bottom Dyke

The hauntingly quiet and atmospheric earthwork is now a scheduled monument. It was probably constructed between AD 5 and 40 by the Catuvellauni to demarcate their land. It is still clearly defined with a depth of up to 10 metres and a width of 30 metres. The stretch in the photographs runs for half a mile between the 'Ancient Briton' crossroads just north of Beech Road to where it is crossed by the railway at Sandridge. A footpath runs for the full half-mile length of this stretch of dyke. In 1461 it was used as a defence by the Earl of Warwick (Warwick the Kingmaker) at the Second Battle of St Albans. As you walk along the dyke, and reach the railway embankment, it is possible that here were buried a number of victims of the battle. There are unproven accounts of human remains and battle debris being unearthed in the 1860s.

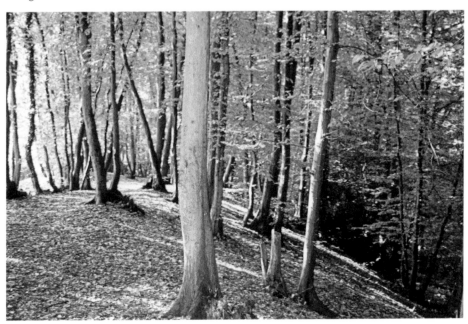

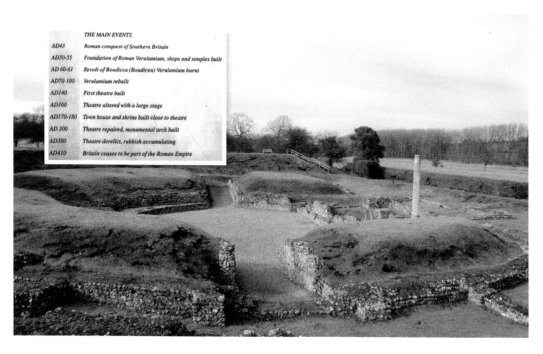

Roman Theatre of Verulamium

The Roman Theatre of Verulamium was built in about AD 140 and was a theatre rather than an amphitheatre. It was extended in about AD 180, and again in AD *c.* 300. The theatre could seat 2,000 spectators. The ruins in the pictures were unearthed in 1869 and excavated in 1834. The remains are located near St Michael's Village and the Verulamium Museum along the original Watling Street.

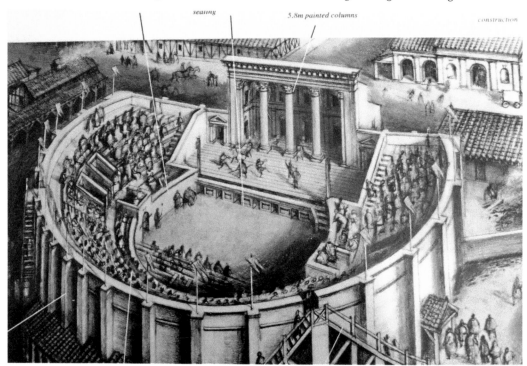

seating 5.8m painted columns construction

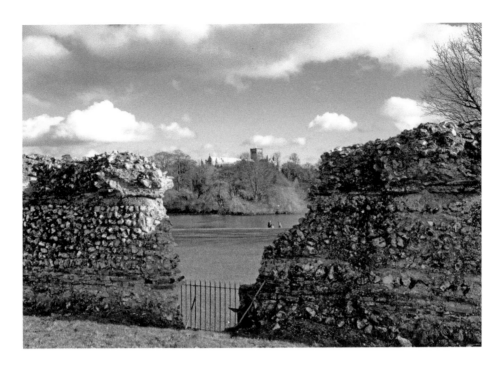

The Roman Wall

The Roman Wall is situated in what is now Verulamium Park, and from here there is a spectacular view of the Abbey. Built AD 256–70, it was 5 metres high, with a parapet and walkway on top, and it extended for 2 miles. Other sections still survive. Situated in the immediate vicinity are the remains of a major 1,800-year-old town house hypocaust with a mosaic. The second photograph taken next to the wall shows the building that covers the mosaic. It has a small display of finds and was opened in 2005.

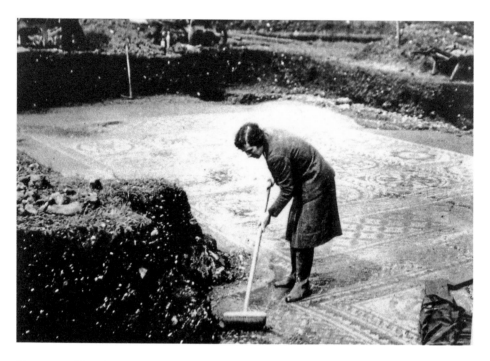

Hypocaust Mosaic

Above, Tessa Wheeler, wife of Mortimer Wheeler, is sweeping the hypocaust mosaic during excavation in 1932. Below is the mosaic floor which contains around 220,000 tesserae. It is likely that this was the home of an official or aristocrat. It has been suggested that the mosaic took two seasons to lay, as indicated by a change in tesserae colour and some laying 'mistakes'.

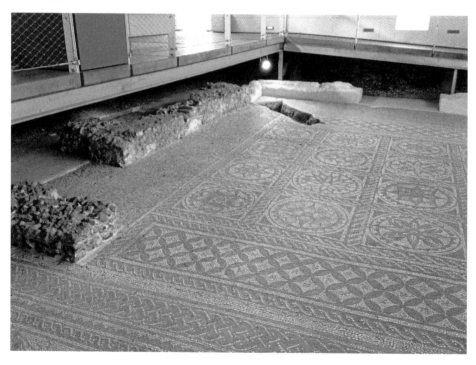

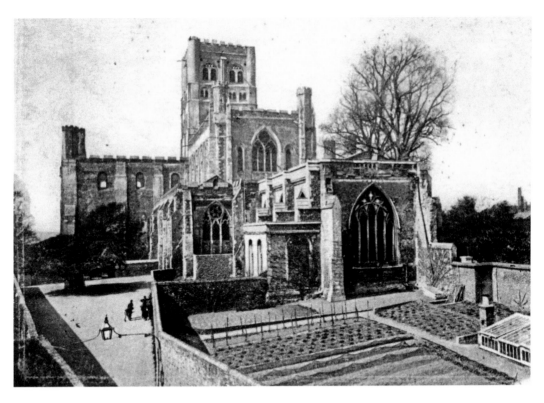

St Albans Abbey Sumpter Yard
Access to the Sumpter Yard is via Holywell Hill opposite the White Hart, as it has been for many centuries. The old photograph shows the yard in 1868 before the yard was enlarged. The cedar tree shown was planted by the Dowager Lady Spencer on 25 March 1803. The modern photograph shows the same view in 2012.

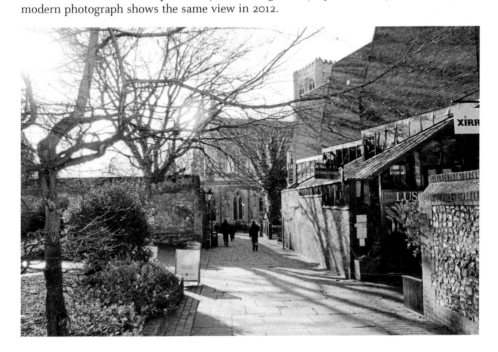

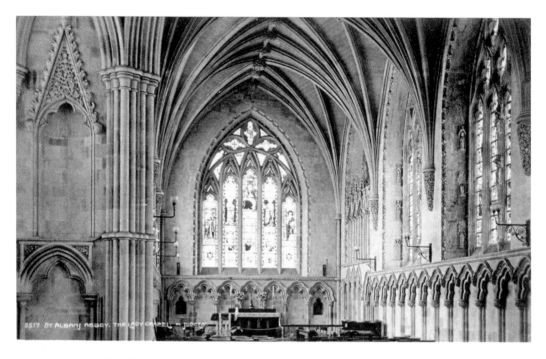

The Lady Chapel

The Lady Chapel was, until restoration of the Abbey, separated from the rest of the church and used as a school. A nineteenth-century visitor commented: 'the arches have been walled up, and a passage made for the use of the town, between the east end and the Chapel ... it has been much neglected, and appropriated as a school-room, and the original pavement covered with a wooden floor.' He continued: 'No sepulchral memorials can consequently be seen; but it is believed that many of the nobility and gentry who fell at the two sanguinary battles of St. Alban's repose beneath.'

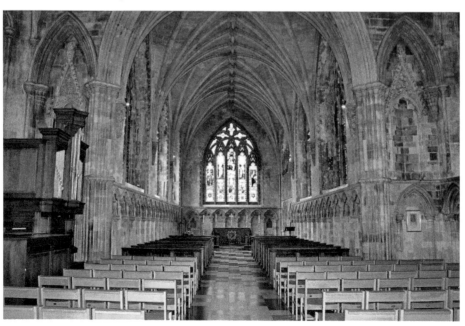

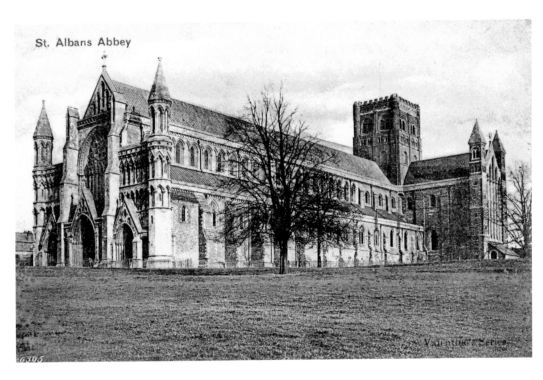

St Albans Abbey I
The Abbey shortly after restoration in 1905 and the same view in 2012.

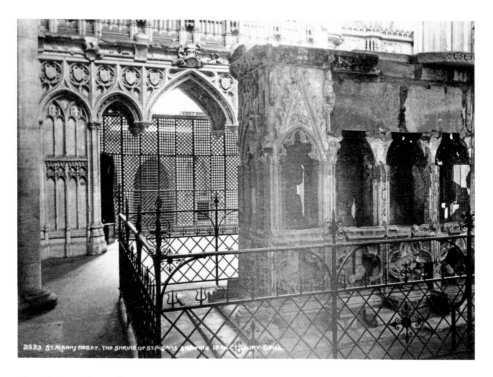

The Shrine of St Alban, c. 1905

The Shrine of St Alban itself deserves a history in its own right. The *Victoria County History* tells us: 'The marble *tumba* or pedestal which carried the shrine of St. Alban was broken in pieces after the Suppression, (Henry VIII) and most of its fragments were built into the blocking of the eastern arches of the feretory, where they were discovered in 1872, and fitted together so that the general design has been recovered.' In 1993 more recently found fragments were added.

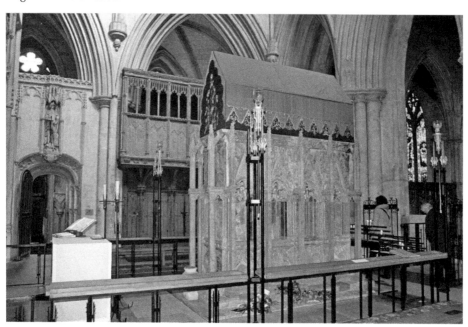

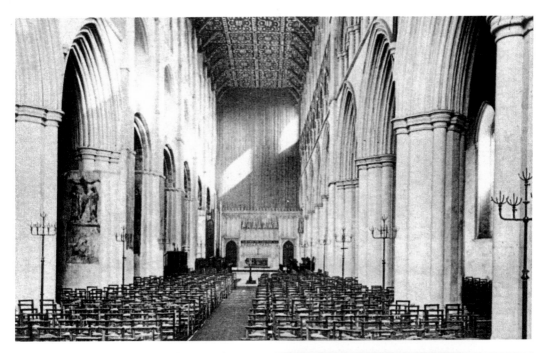

Abbey Nave
The first photograph dates from the period of restoration in the 1880s. Services were conducted in the nave during this period. A contemporary report of the extensive renovation work observes that 'in excavating the floor of the nave two mutilated stone coffins were found, about three feet from the surface, and fragments of tiles are discovered occasionally with other interesting *debris*.'

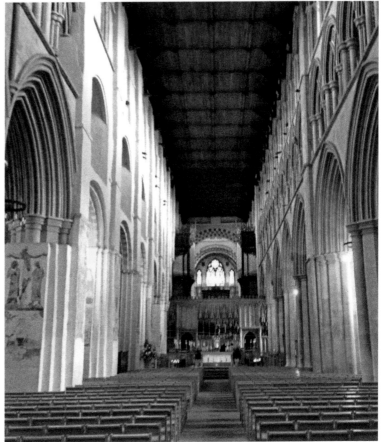

ENTRANCE TO OUR LADY'S CHAPEL, ST. ALBAN'S ABBEY.

The etching dates from 1800 and shows figures through the Waxhouse Gate opposite the Clock Tower. The 1908 *Victoria County History* tells us: 'Branching off south to the abbey through an archway, formerly the Waxhouse Gate, is what is now wrongly called the Cloisters, its former name being Schoolhouse Lane. Of the Waxhouse Gate itself part of the base of the walls remains, but the arch which now represents it is a plain round-headed eighteenth-century opening.' Through the Waxhouse Gate, to the left of the Abbey, lies the entrance to the Vintry Gardens. During the Middle Ages the gardens were where the monks were buried. The 1634 Hare map shows that the gardens had been enclosed since that time.

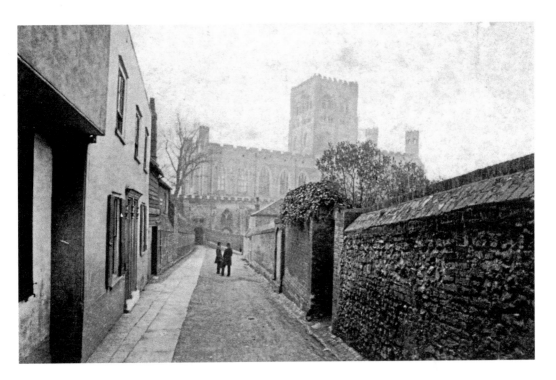

Waxhouse Gate II

The old photograph dates from *c.* 1880. Of the Waxhouse Gate itself, part of the base of the walls remains, but the arch which now represents it is a plain round-headed, eighteenth-century opening. The photograph below was taken with the Abbey behind looking towards the Waxhouse Gate and Clock Tower. The Vintry Gardens are behind and to the left of the figures in the first picture.

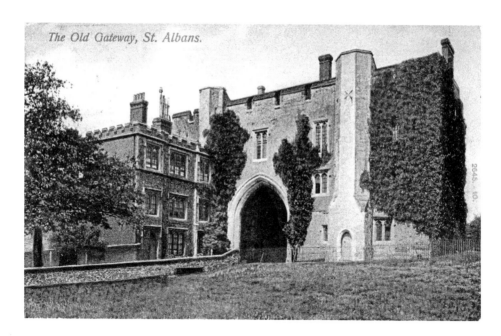

The Old Gateway, St. Albans.

The Abbey Gateway

The Abbey Gateway is built of Roman tiles and flint, and is the only remaining part of the monastery, to which it was the gateway. It was built around 1360, whilst Thomas de la Mare was Abbot. It was besieged in 1381 during the Peasants' Revolt, one of the leaders of which, the radical priest John Ball, came from St Albans. The Abbot John of Whethamstede (died 20 January 1465), from a window of the gateway, observed and recorded the vicious fighting during the First Battle of St Albans which was taking place a few hundred metres away around the Clock Tower and Market Place. It also housed the third printing press in England from 1479. The building was used as a prison between 1553 and 1869. Since 1871 it has been part of St Albans School. The postcard dates from *c.* 1905, the photograph, 2012.

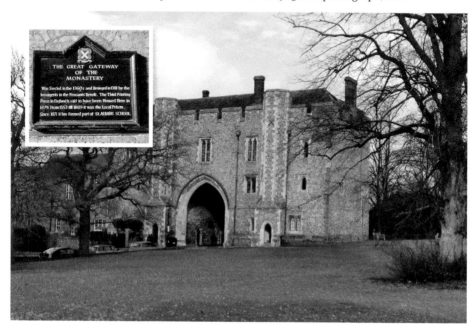

Abbey Ceiling

The top photograph shows the ceiling of the tower of the Abbey Church which dates from the sixteenth century. Included in the design are the roses of York and Lancaster. St Albans and the Abbey were very closely involved in the Wars of the Roses. A number of important participants were buried under the floor of the Lady Chapel. The lower illustration shows a number of medieval paintings in the Cathedral nave that date from *c.* 1330.

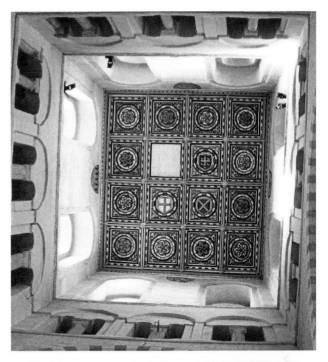

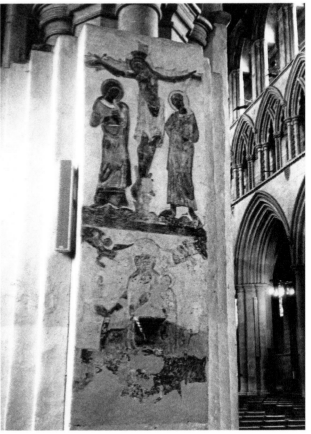

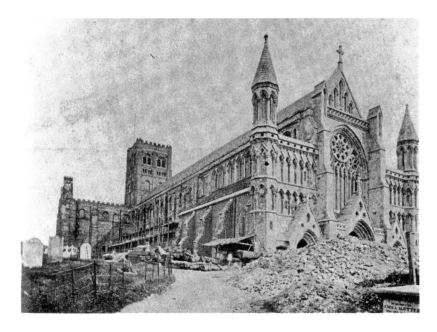

St Albans Abbey II

The Abbey originated on this site because during the reign of the Roman Emperor Diocletian, Albanus, a Roman official, protected a Christian preacher and was ultimately executed on 20 June AD 293. His body was buried where subsequently 'a small church' was erected. In AD 792 Offa, King of the Mercians, to expiate his sins, was told to 'erect a fair monastery to the memory of the blessed Alban, in the place where he suffered martyrdom'. Offa commenced a search for the forgotten remains of Albanus and 'assisted by clergy and people ... and [a] light from heaven ... the ground was opened and the body of St Alban discovered...' Offa used much Roman material from Verulamium to build the Abbey. Over the centuries the Abbey deteriorated badly, and under local resident Lord Grimthorpe of Batchwood Hall, the restoration was undertaken in the 1880s. The photograph above shows rubble waiting to be removed in 1885.

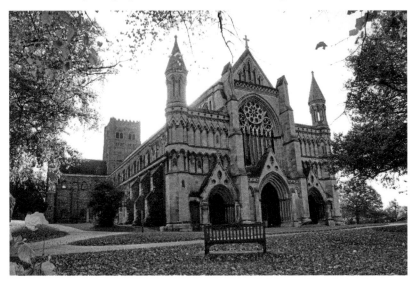

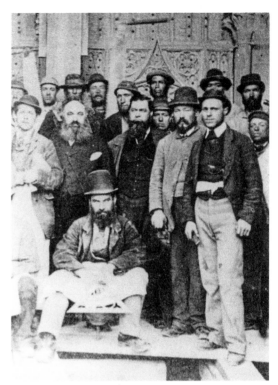

Sumpter Yard Entrance to the Abbey
A photograph from 1880 of a group of
workmen employed for the renovation
of the Abbey. The picture below shows
the Sumpter Yard entrance, off Holywell
Hill, into the Abbey, *c.* 1870, before the
renovations.

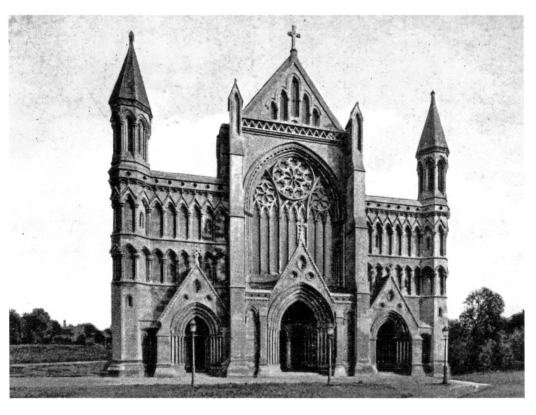

St Albans Abbey III

The postcard of the Abbey dates from *c.* 1905 and the modern illustration, taken from Romeland, shows the Abbey in relation to the fourteenth-century Abbey Gateway.

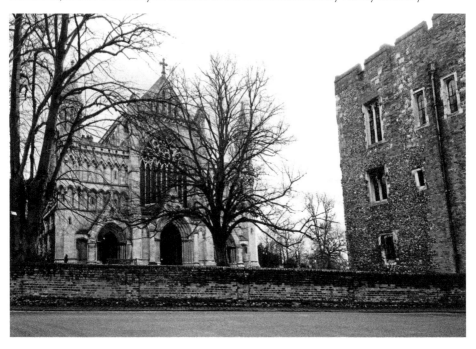

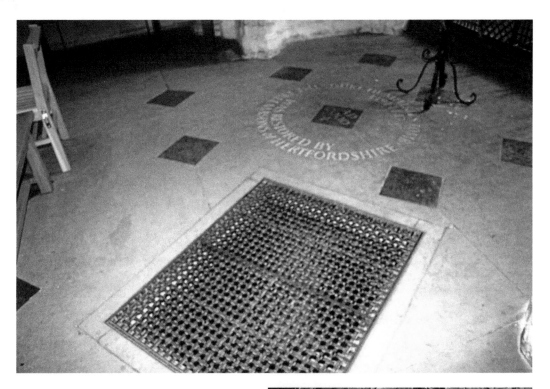

Duke Humphrey

The first photograph is of the tomb of Duke Humphrey, next to the St Alban shrine. The grate covers the steps into the vault. A guide book from 1880 tells us that in 1703 the body was 'discovered' in the vault and found to be lying in pickle in a leaden coffin enclosed in a wooden one. It is reported: 'When the coffin of good Duke Humphrey was opened, the multitude pressed forward eagerly to taste the liquor in which the body was preserved, until the corpse was left quite bare and dry, and of course soon mouldered away.' In 1880 we are told that visitors 'could still by way of the steps (still visible) enter the tomb.' The second illustration is of a knight which dates from the fourteenth century and is a depiction of St George.

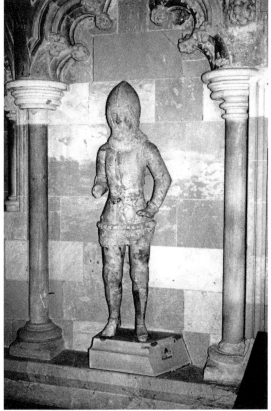

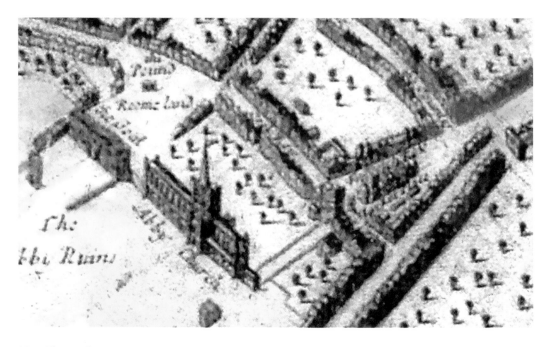

Map Illustrations, 1700

The first illustration is a detail from the John Oliver map of St Albans, dating to *c.* 1700. This shows the Abbey and surrounding area in detail. The lower illustration is a detail covering the area around St Peter's Church at the north end of St Peters Street.

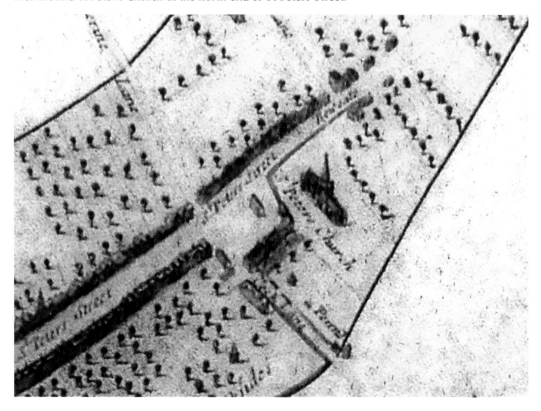

First Battle of St Albans

Henry VI raised the Royal Standard, a declaration of war, in the vicinity of what is now the Boots store in St Peters Street. It was here that he was injured in the neck by an arrow. Four of the King's bodyguard were killed and the Royal Standard was abandoned. It was in Sopwell Lane (bottom) that the Earl of Salisbury attacked the defences held by Lord Clifford's men.

Market Place Fighting

Fighting in the Market Place and Town Square was fierce. At the northern end of the town York's troops entered St Peter's Street killing all that stood in their way. Abbot John of Wheathampstead, observing the fighting from the Abbey Gatehouse a short distance away, described the scene: 'Here you saw one fall with his brains dashed out, there another with a broken arm, a third with a cut throat, and a fourth with a pierced chest, and the whole street was full of dead corpses.' Somerset took shelter in the Castle Inn just off the Market place. He was soon surrounded and died fighting. The plaque is on the wrong building and should be opposite!

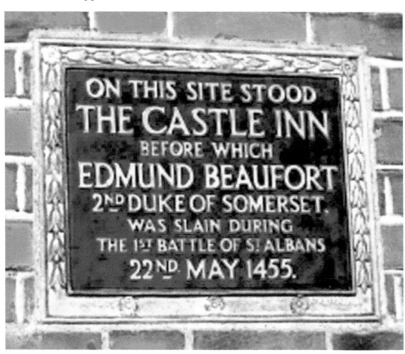

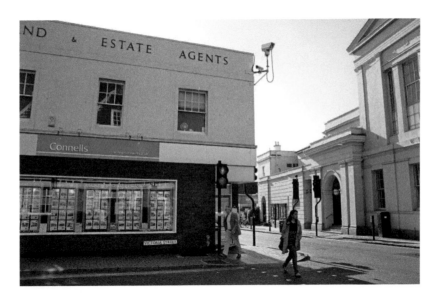

The Death of the Duke of Somerset

The top photograph of Connells opposite the Skipton is where the Duke of Somerset was killed. A contemporary source describes his demise: 'York's men at once began to fight Somerset and his men, who were within the house and defended themselves valiantly. In the end, after the doors were broken down, Somerset saw he had no option but to come out with his men, as a result of which they were all surrounded by the Duke of York's men. After some were stricken down and the Duke of Somerset had killed four men by his own hand, so it is said, he was felled to the ground with an axe, and at once wounded in so many places that he died.' In the background to the right is the site of the old Moot Hall. The photograph below depicts the River Ver. St Michaels was the scene in the Second Battle of St Albans where at dawn on 17 February 1461 the Queen's army attacked the Yorkists, already occupying the town. They crossed the River Ver, in the vicinity of St Michael's church, advanced up Fishpool Street, Romeland Hill and George Street until they reached the Market Place. They were fired on by Yorkist archers from the windows of the surrounding buildings in the town centre. The Lancastrians were pushed back down George Street and regrouped at the River Ver ford.

Keyfield and White Hart Tap

The opening conflict of the Wars of the Roses happened in St Albans. On 22 May 1455, the First Battle of St Albans resulted in a Lancastrian defeat after King Henry VI occupied the town, but was ousted by Yorkist forces led by the Earl of Warwick after a skirmish in the town centre. By 7 a.m. the Duke of York, Salisbury and Warwick 'with divers knights and squires' arrived at Key Field, now the site of a car park best seen from the outdoor terrace of the White Hart. A couple of hours later the royal party marched into St Peter's Street.

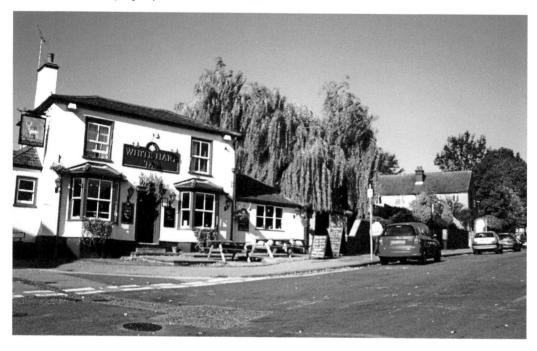

Bernards Heath and Market Area

The fighting on Bernards Heath became a grim slugging match, with both sides anxiously waiting for reinforcements. It was here that the Yorkist forces broke and fled. The site of the gallows and old burial ground are immediately to the left under what is now a block of flats. Below, Nomansland Common where the Yorkists rallied for a last stand and the exhausted Lancastrians withdrew to St Albans. Warwick probably retreated down Ferrers Road, to the right of the car park.

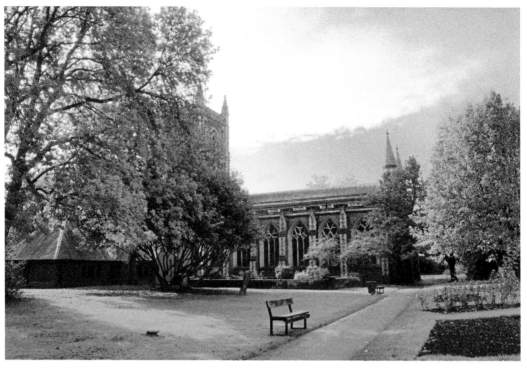

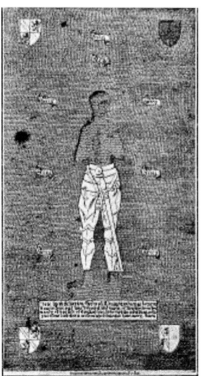

Churchyard and Entwistle Brass

The northern end of St Peters churchyard is the likely burial place of many of the fallen. An early source states: 'This Church and Churchyard was stuffed full with the bodies of such as were slain in the two battles, fought here at St Albans.' Below, the brass of Sir Bertine Entwistle killed by a severe sword wound to the shoulder in the First Battle and buried under the floor of St Peter's. The brass was damaged by builders in 1797. The remaining lower half is in the British Museum. (Courtesy Tom Entwistle)

R BERTINE'S MEMORIAL BRAS
Restored

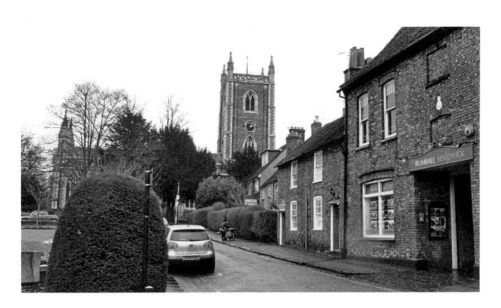

St Peter's Church I

St Peter's Church was originally founded around AD 948 by Abbot Ulsinus of St Albans. It was built at the same time as St Stephen's and St Michael's churches, to receive pilgrims and to prepare them for their visit to the shrine of St Alban within St Albans Abbey. The church started to seriously deteriorate and in 1799 the tower had to be lowered to the level of the crossing arches. In 1801 the belfry floor fell in and a new tower was erected. In 1893, after he had completed his restoration of the Cathedral and Abbey Church, Lord Grimthorpe took it upon himself to restore St Peter's at his own expense. Reportedly only an hour-and-a-half's examination of the church enabled him to decide 'what is necessary and desirable to do in the way of restoring it to a safe and creditable condition as far as the modern alterations leave it possible'. Below is a watercolour painting of the church and green in 1917.

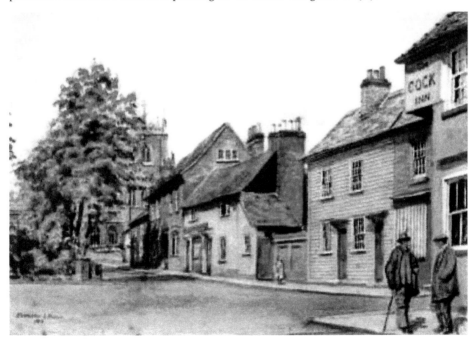

St Peter's Church II

The old photograph of St Peter's Church was taken before Lord Grimthorpe's restoration work of 1894–95. According to Matthew Paris, a thirteenth-century abbot, Ulsinus founded St Peter's in 948. In 1799 the tower had become so dangerous that it was taken down to the level of the crossing arches and finally in 1801 the belfry floor fell in. The new tower, which was erected in brick, was essentially as is seen today in size and shape. In 1893, Lord Grimthorpe's restoration left an essentially Victorian church with some traces of earlier centuries.

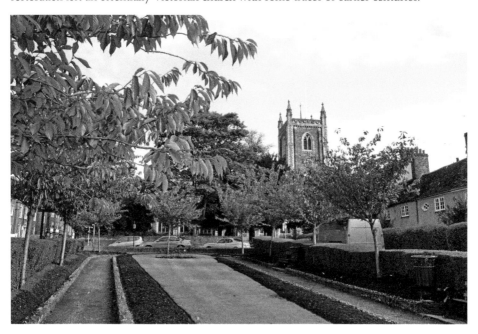

St Peter's Church III The illustration is a detail from the Hare map of St Albans, the earliest known. It shows St Peter's Church and almshouses in 1634. The modern photograph shows the church in 2012.

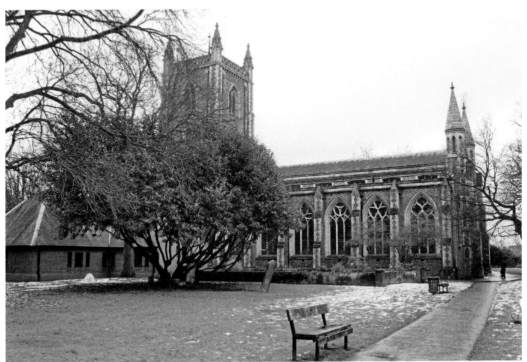

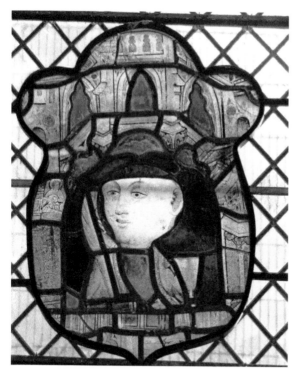

St Peter's Stained Glass and Brasses
The figure in the window of St Peter's
Church is reputed to be the Abbot of
St Albans, John of Wheathamstead,
a participant in and recorder of the
events of the Battle of St Albans. He
died in 1464. The lower photograph
depicts restored fragments of
fifteenth-century glass.

St Peter's Church Interior

The photograph was taken shortly after
1908. There are a number of early brasses
displayed on the walls. The interior today
gives little clue to the immense amount
of history that the church has witnessed.
Participants of the Wars of the Roses lie
under the aisles including Sir Bertine
Entwistle whose sword was said to have
been found when digging took place in
the chancel. His brass was removed in the
eighteenth century. The Entwistle family
provided the author with a copy of Sir
Bertine's brass which is now in the British
Museum.

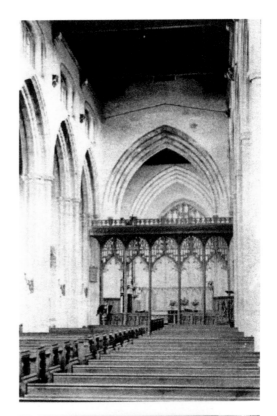

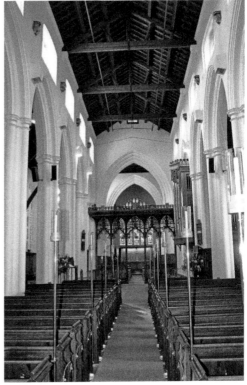

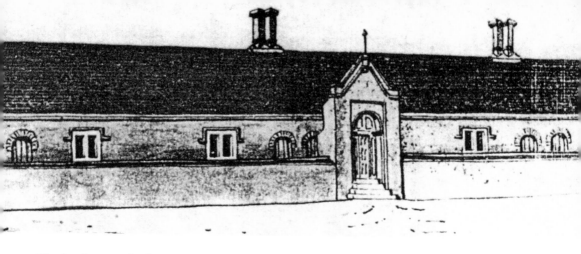

The Pemberton Almshouses

The 1908 *Victoria County History* says of the Almshouses: 'Opposite (St Peter's Church) are the Pemberton Almshouses, built of red brick, of a single storey, with square-headed mullioned windows of two lights, and six plain round-headed doorways. They are set back a little from the road, with a garden in front bounded by a low red-brick wall, and entered through a tall central gateway, over which is an inscription, dated 1627, recording their foundation by Roger Pemberton, who is buried close by in St Peter's Church. Tradition says that the iron spike over the gateway represents the shaft of an arrow, and that the founder once shot a widow by accident, and built the almshouses for an atonement. There seems, however, to be no foundation for this story.'

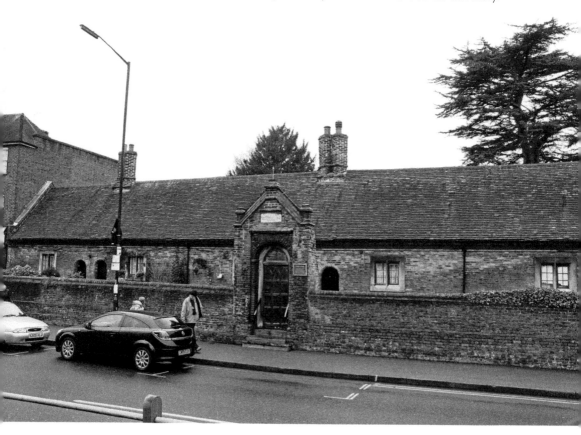

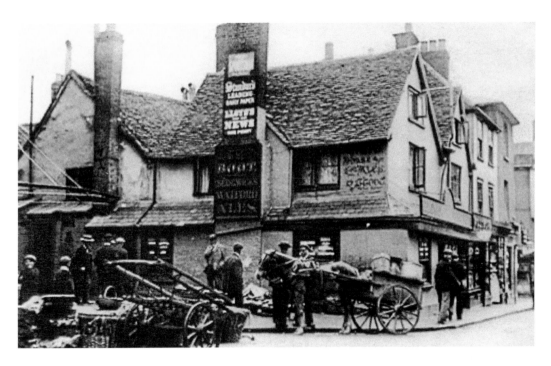

The Boot

The Boot, a public house, was originally built in c. 1500 in the Market Place. The building was originally made up of two timber-framed buildings. Each building had two ground-floor rooms with chambers over on the first floor. The upper floors projected out on the front and north sides. It is first recorded as a licensed house in 1719. In 1756, it could provide accomodation for the billeting of four soldiers but had no stabling.

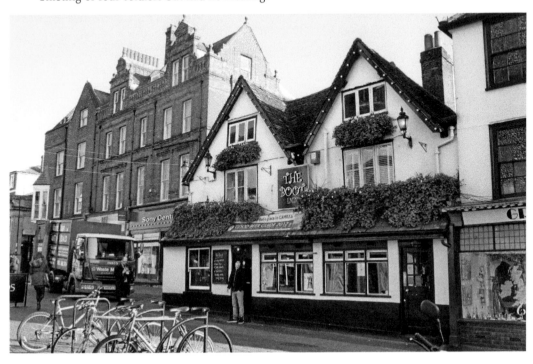

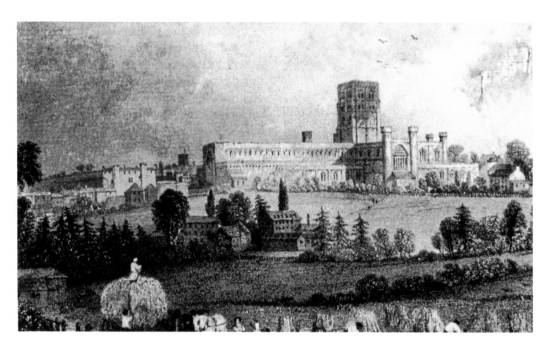

Harvesting, 1868
Harvesting in what is now Verulamium Park. The illustration dates from 1868 with a modern view in 2012.

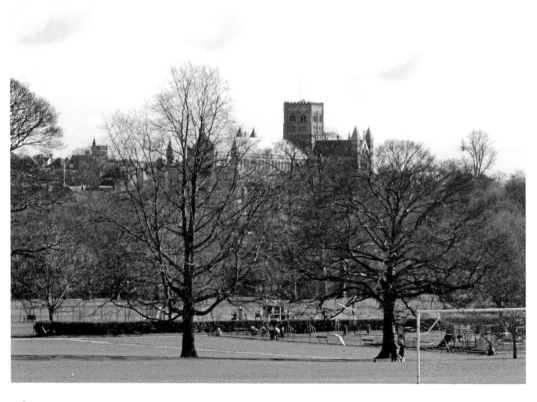

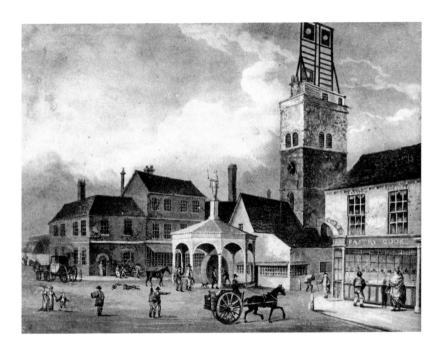

The Market Place I

The 1908 *Victoria County History* tells us: 'Around the Market Place, which was apparently on the same site as it was at the time of its enlargement by Abbot Walsin in the tenth century, stood the principal buildings. At the south end was the Eleanor Cross, Queen Cross, or Market Cross erected by Edward I to commemorate the resting-place of the body of Queen Eleanor on its journey from Lincolnshire to Westminster in 1290, on the site of which stands a drinking fountain erected by Mrs Worley in 1874. In the seventeenth century the cross was allowed to get out of repair, and about 1700 the last vestiges of it were carted away to make room for the Market Cross erected in 1703, an octagonal building with a roof supported upon eight columns above which was the figure of Justice, and within it was the town pump worked by a large wheel. This building was taken down in 1810, but the pump remained for a time.'

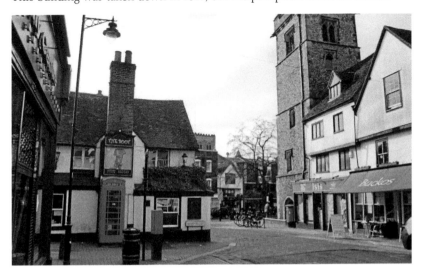

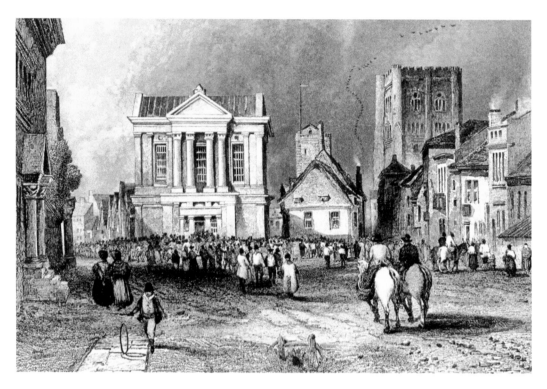

Town Hall

The Town Hall (centre) occupies the site once occupied by the Moot Hall, now the area taken by the Judges Robing Room. The Town Hall, built as a combined court house and town hall, was opened in 1831. The building to the right, still standing, is 'The Gables', built in 1637. The 1835 illustration uses artistic licence with its proportions.

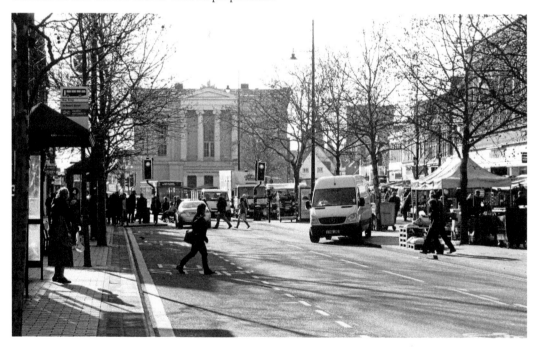

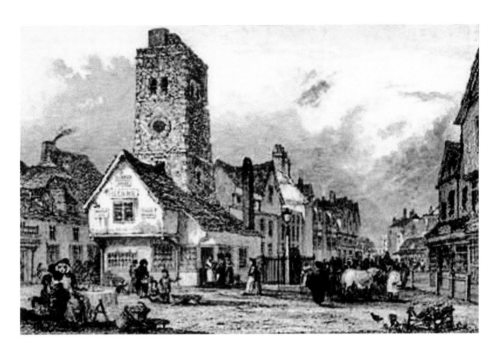

Clock Tower I

Steel etching by George Cooke in 1826 of the Clock Tower viewed from High Street looking up Market Place. The etching shows the shop in front of the tower, the pump and a gas light within railings, and a market in progress in the Market Place. Further down the Market Place the old open-sided Market House can be seen. This building was knocked down and replaced with the Corn Exchange building in 1857. The photograph illustrates the integration of old and new. The arch is the entrance to Christopher Place, a modern shopping centre.

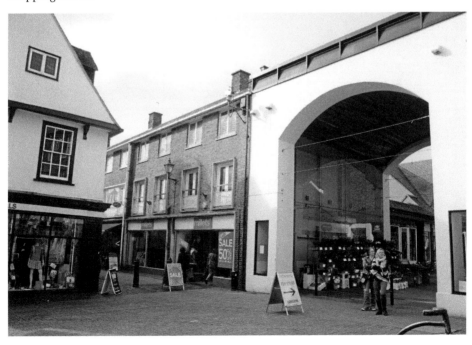

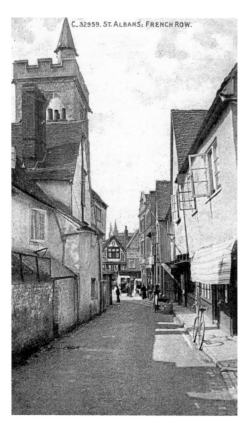

The Market Area

Originally the market area was divided into spaces for the booths or stalls of different trades: the Butchery, the Flesh Market or 'Fleshambles', the Fish Market or Fish Shambles, the Malt Cheping, the Corn Market or Wheat Cheping, the Leather Shambles, the Pudding Shambles, the Wool Market, and the Cordwainers or Coblers Row. The stalls, which at first were temporary, gradually became permanent and eventually regular houses or shops. In this way the Market Place became largely built over, and the houses and courts and alleys between Chequer Street and the street now called Market Place were gradually formed. French Row, also known as Cobblers Row and Cordwainers Row, was in like manner erected, and was built before 1335. The first picture shows, apart from pedestrianisation, how little French Row has changed.

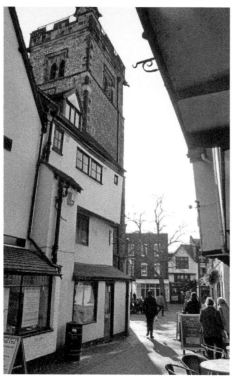

French Row

The buildings in French Row date from the foureenth century. The Fleur-de-Lys inn is where the French King, John, was reputedly imprisoned in 1356 following the Battle of Poitiers, but this is unlikely. In 1420–40, Abbot Wheathampstead paid for the construction of a brewery in French Row. Excavations prior to the construction of Christopher Place behind the western side of French Row/Market Place revealed the stone footings for fourteenth/fifteenth-century timber. The photograph dates from 1890.

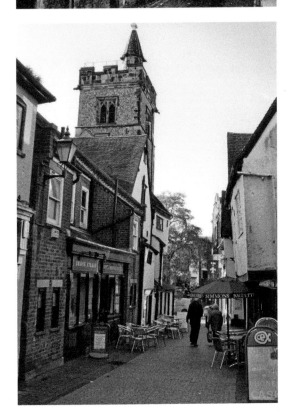

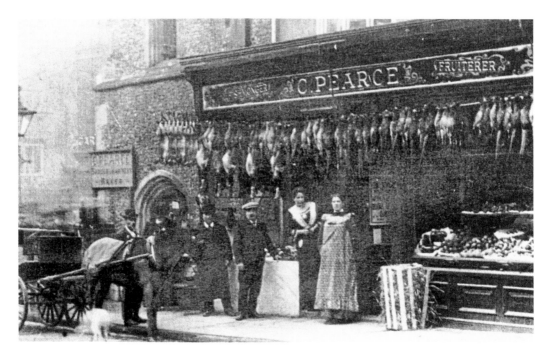

Clock Tower II

C. Pearce, fishmonger and fruiterer, is situated at the foot of the Clock Tower, *c.* 1910. There have always been shops in this location and in the ground floor of the Clock Tower itself. The 1908 *Victoria County History* states that 'the ground story of the Clock Tower, [is] now used as a saddler's shop'.

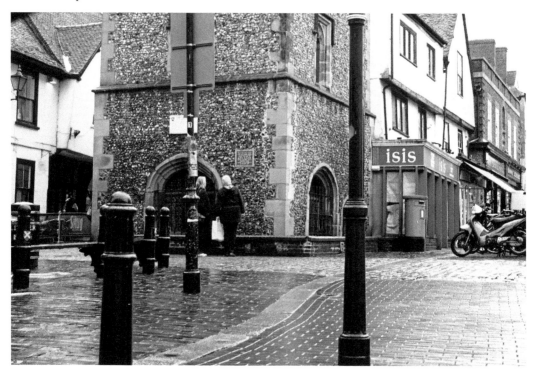

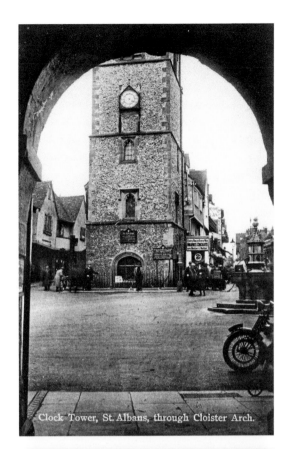

Clock Tower, St. Albans, through Cloister Arch.

Clock Tower III

The Clock Tower as seen in 1916 through the Waxhouse Gate, and again in 2012.

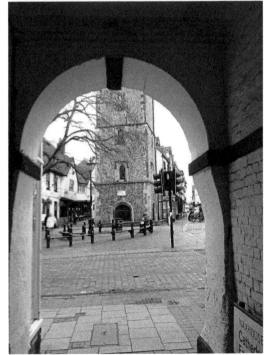

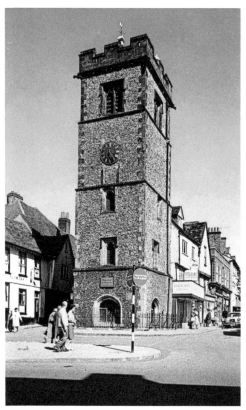

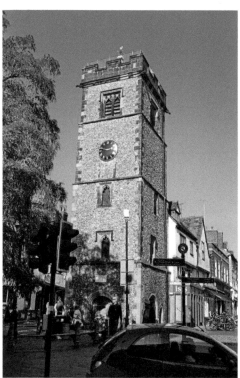

Clock Tower IV

The timelessness of the Clock Tower as a central feature can be seen. The *Victoria County History* of 1908 informs us: 'The ground story of the Clock Tower, now used as a saddler's shop, has open arches on the south and east, and small doorways at the north-east and north-west, leading to newel stairs in the angles of the tower. On these the north-west stair is carried up to the top of the tower, ending in an embattled turret, but the north-east stair ends at the first floor, and connects with the other stair by a passage carried across the north side of the tower, now blocked at its west end. There are fireplaces in the west walls of the first and second floors, and both floors are lighted by cinquefoiled windows on the south and east. The third floor has a like window on the north side only, and the fourth floor, which contains the two bells, has square-headed two-light windows on each face, with modern tracery of quatrefoiled circles over cinquefoiled lights. The old floors are in a great measure preserved, with central bellways. The tower is finished with an embattled parapet and short leaded spire, and though much of its external stonework has been renewed, is a most interesting and picturesque building.'

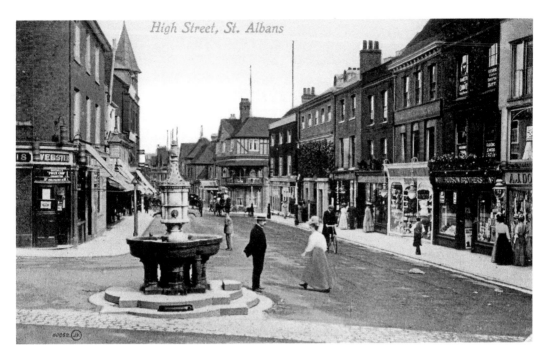

High Street, St. Albans

High Street and Fountain

The postcard dates to 1905. In the foreground is Mrs Worley's drinking fountain. Mrs Worley was a wealthy widow who gave this drinking fountain to the town in the 1870s. Originally it was situated in front of St Albans Clock Tower on High Street. However, as traffic increased it became too obstructive and was moved in the 1920s. It was found on a council tip and was relocated behind the old prison in Grimston Road.

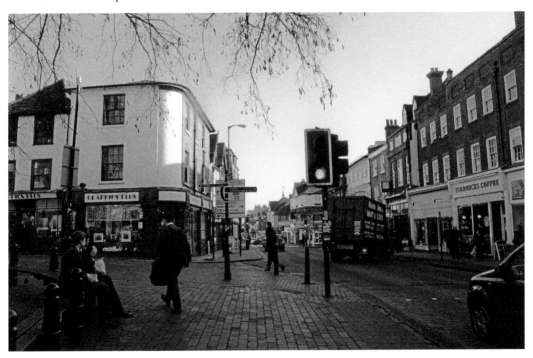

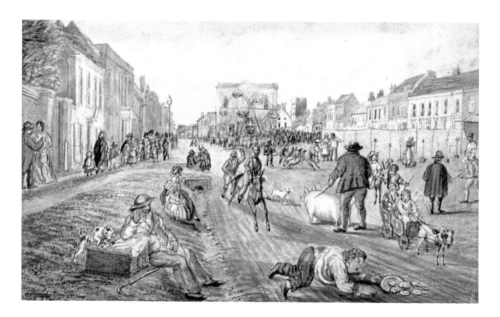

Michaelmas Fair

'The Michaelmas Fair, St Albans, 1852,' by J. H. Buckingham 1800–81. Buckingham's rough and ready work shows the approach to St Albans up Holywell Hill, a sight which horse and driver alike must have dreaded (extra horses could be hired for the ascent). Fortunately, he never 'tidied' his scenes, and so we see the traffic as it must have been, with pedestrians, horses, cattle, carts and carriages using the road at random. The view of St Peter's Street shows a fair with stalls and booths, a Ferris wheel and a coconut shy or 'Aunt Sally'. The two- and four-legged traffic includes donkey rides and a children's toy carriage drawn by a goat. The roadway is rough and wide, with no very clear demarcation between carriageway, pavement, and fair; the same could be said on market days. (St Albans Museum)

Holywell Lodge

At No. 41 Holywell Hill on the east side of the road is Holywell Lodge. The Lodge is a grade II listed building, with a frontage that dates to the early nineteenth century. It possibly hides a building of earlier origin. The Lodge is a remaining echo of the former Holywell House which was knocked down in 1837 and stood close by.

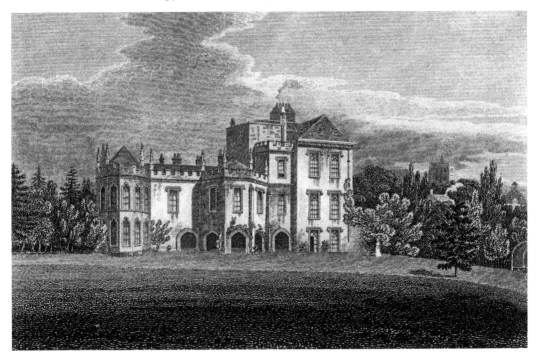

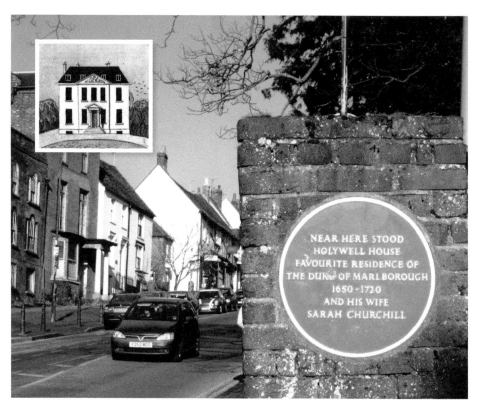

Holywell House

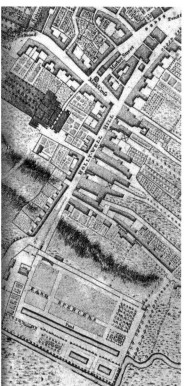

At the bottom of Holywell Hill stood Holywell House. The 1908 *Victoria County History* tells us: 'Holywell Lodge (Mr Thomas Kent), and Torrington House (Mr A. F. Phillips), which last is on a part of the site of Holywell House, the seat of the Rowlatts and afterwards of the Jennings family, demolished in 1827. Sarah Duchess of Marlborough was probably born here, and she and the celebrated duke occasionally lived at this house. Miss Ormerod, the entomologist, lived in Torrington House for many years before her death, and here she carried on her investigations as to insect pests. At this point it may be noticed that a side road curves off to the west and meets the main road again a little lower down. This diversion was caused by an extension of the grounds of Holywell House into the roadway. The road, however, was reinstated in its direct course when Holywell House was pulled down.'

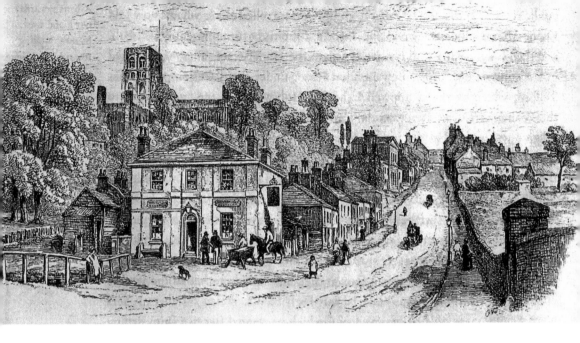

Couching Houses

Coaching was a key element for St Albans, hence the number of inns which offered stabling. The St Albans Turnpike Trust in 1796 re-routed the London Road bypassing Holywell Hill. The top illustration dates from *c.* 1850 and shows Holywell Hill looking to the north. After the demolition in 1837 of Holywell House, formerly located right foreground, Holywell Hill was straightened.

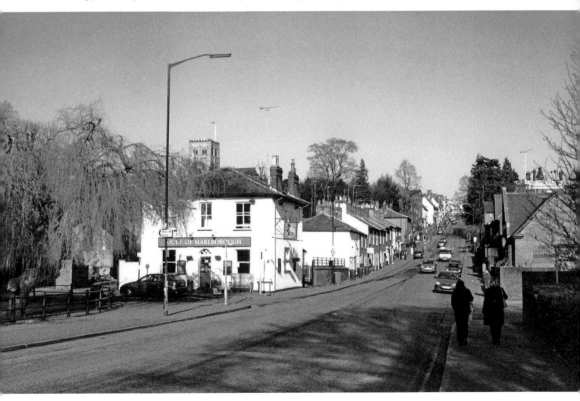

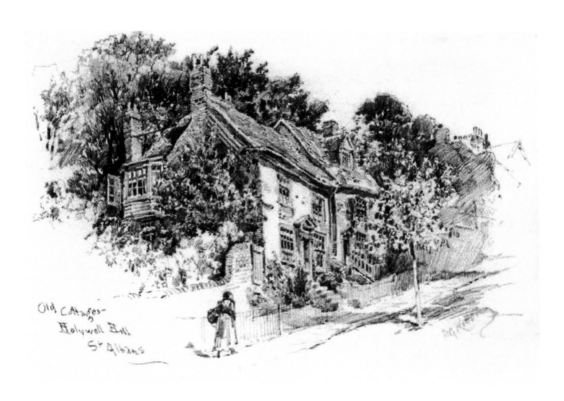

Holywell Hill I
Above is a pencil drawing, *c.* 1900, of two cottages in Holywell Hill which remain to this day.

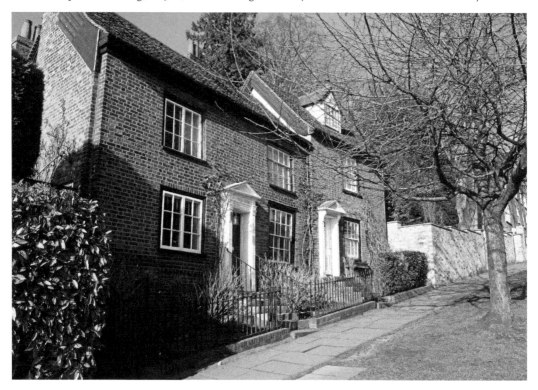

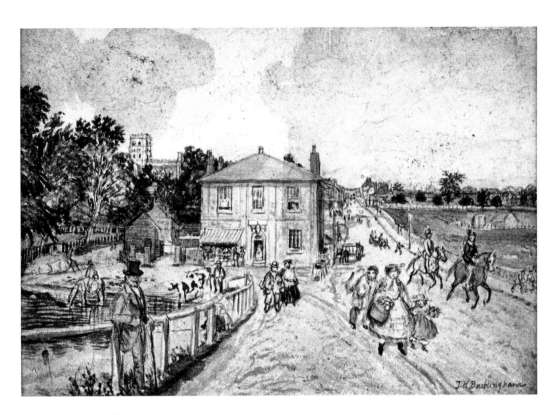

Holywell Hill II, *c.* 1850

The view looking up Holywell Hill from the bridge over the River Ver towards St Albans town centre with St Albans Abbey in distance and figures on foot and horseback. Note the open field on the right-hand side of the road. The illustration is by John Henry Buckingham.

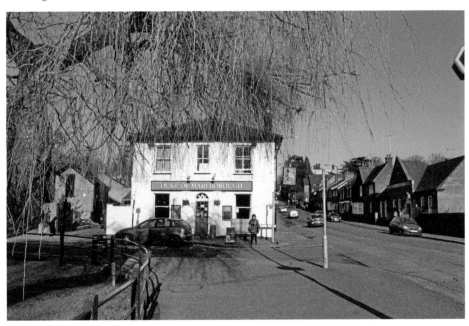

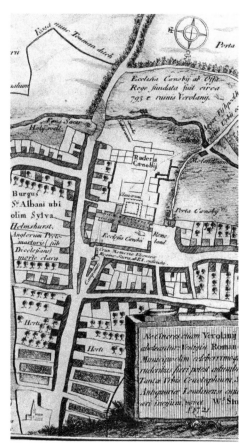

A Detail from the Stukely Map of 1721
St Peter's Church, St Peter's Street, can be
seen bottom left, the Abbey, Romeland, and
the Verulamium ruins are shown in the top
section. The second map dates from 1810. The
detail shows that St Albans had changed very
little in over a century. Holywell House can
be seen clearly at the bottom of Holywell Hill,
as can the full extent of the Abbey orchards
opposite.

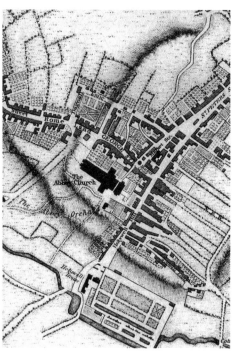

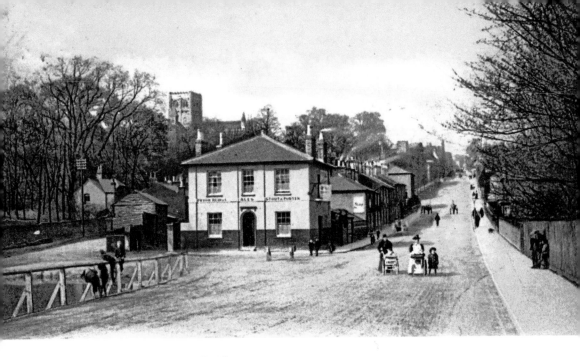

A View looking up Holywell Hill
The postcard dates from *c.* 1905 and shows the Duke of Marlborough pub. The pub dates from *c.* 1825. The 2012 view below is looking from the bottom of the hill towards the city centre.

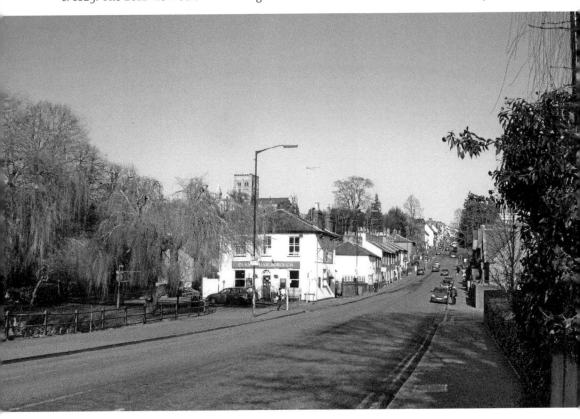

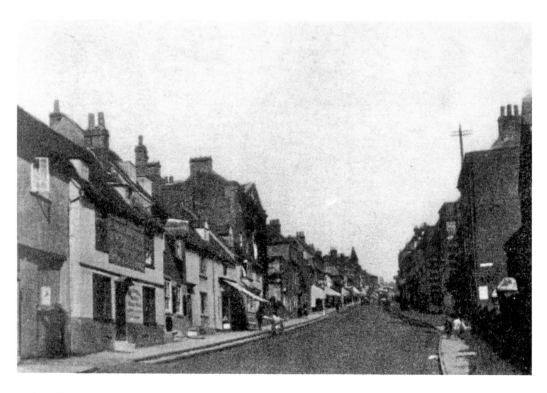

Holywell Street
Holywell Street in 1925 looking towards the centre of St Albans and below is a similar view in 2012.

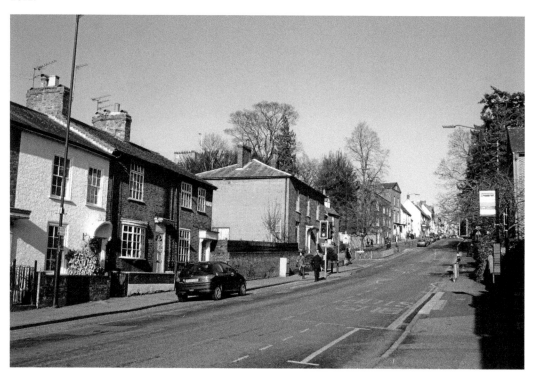

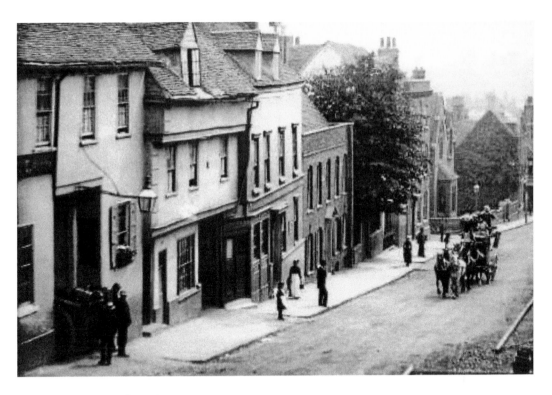

White Hart and Torrington
The sepia photograph, which dates from the 1890s, shows a coach approaching the White Hart from the south. Below is Torrington House on Holywell Hill where Eleanor Anne Ormerod (11 May 1828–19 July 1901), an entomologist, lived for many years before her death.

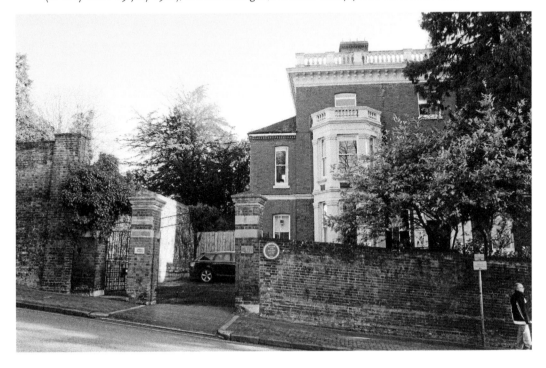

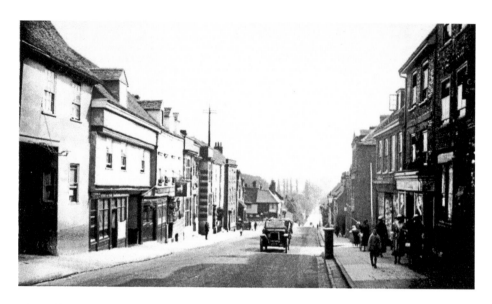

The White Hart, Holywell Hill I

The inn, situated at the top end of Holywell Hill, dates from around 1500. Some notable events have taken place here. In 1792 a traveller commented that it was 'perhaps the best here', but the inn was 'unequalled in filth, inattention and charge'. In 1535 the White Hart, then known as the Hartshorn, was leased by the Abbot of St Albans to John Broke and his wife Elizabeth. The oldest part is on the south and formed part of an inn built around 1500 and then known as the Hartshorn. Below is the courtyard. Most of the outbuildings were destroyed in a serious fire in 1803. In the later nineteenth century a wheelwright worked in the yard. In 1820 Elizabeth Wilson, seated on top of the Northampton Coach, failed to duck as it swept under the entrance and was killed by the impact. Her ghost is said to make appearances. The second photograph shows the courtyard, looking towards the Sumpter Yard entrance to the Abbey in 2012.

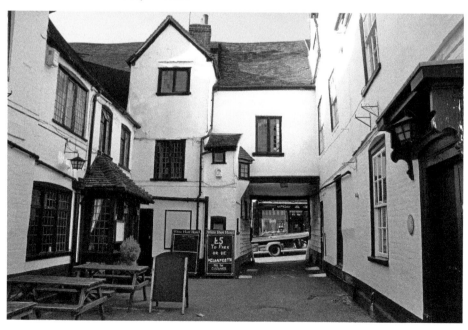

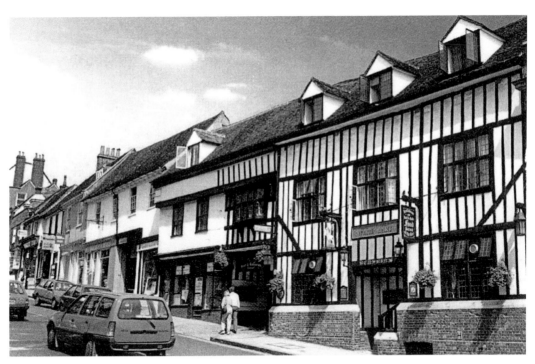

The White Hart, Holywell Hill II
Above is the White Hart in the 1960s looking from south to north. The photograph to the right shows the White Hart Yard in 1898.

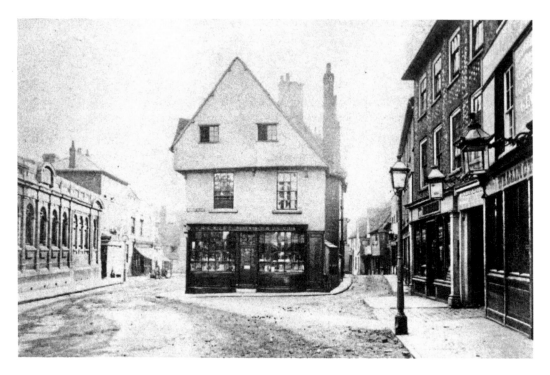

Market Place II

Market Place has been the commercial focus of the St Albans since at least the twelfth century. The old photograph shows the Corn Exchange on the left and the Gables in the centre. The 1908 *Victoria County History* tells us: 'On the east side of the present Market Place stands, detached on all sides, the Corn Exchange, an inartistic building of white brick, which, in 1857, took the place of an ancient open market-house supported on wooden piers. The Gables was threatened with demolition in 1902, but saved by public protest.'

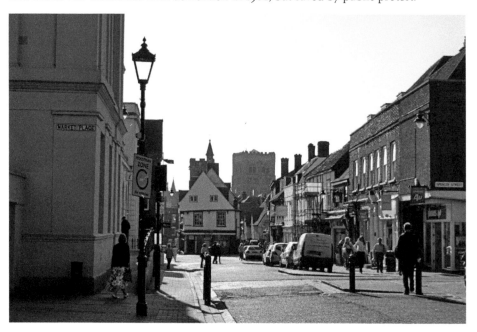

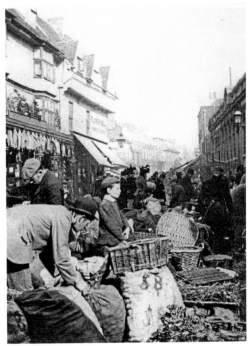

Market Place III, *c.* 1880
The Market Cross with the Abbey in the
background on a postcard dated 1916.

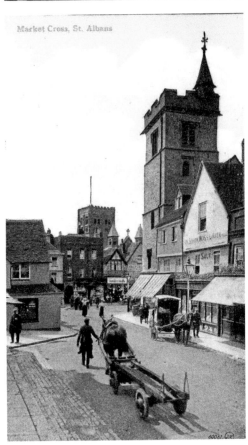

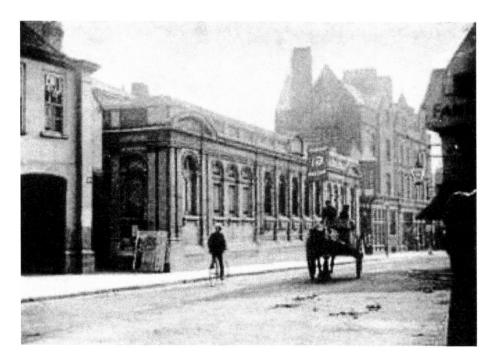

Corn Exchange

The *Victoria County History* of 1908 tells us of the Corn Exchange, now the Reiss building: 'On the east side of the present Market Place stands, detached on all sides, the Corn Exchange, an inartistic building of white brick, which, in 1857, took the place of an ancient open market-house supported on wooden piers.' There had been complaints about this old building for at least half a century before due to its open sides which allowed the rain in, spoiling farmers' sacks of grain. The cost of the new building, £1,470, was raised by public subscription and the new building, designed by Coventry architect James Murray, was opened in September 1857 by the mayor of St Albans, John Lewis.

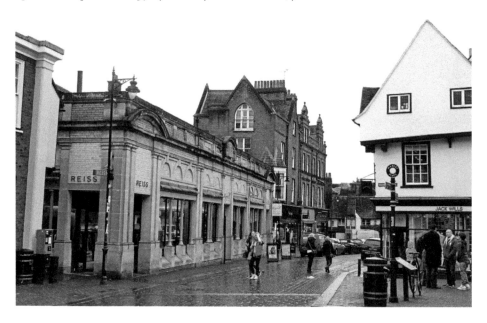

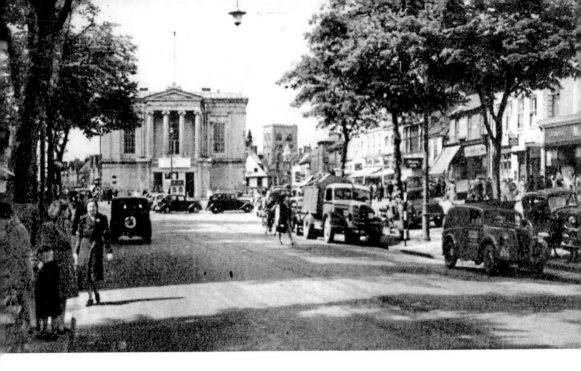

Market Place and Town Hall
A postcard dating from 1948 showing the Market Place and Town Hall approaching a more familiar outlook and a similar view below in 2012.

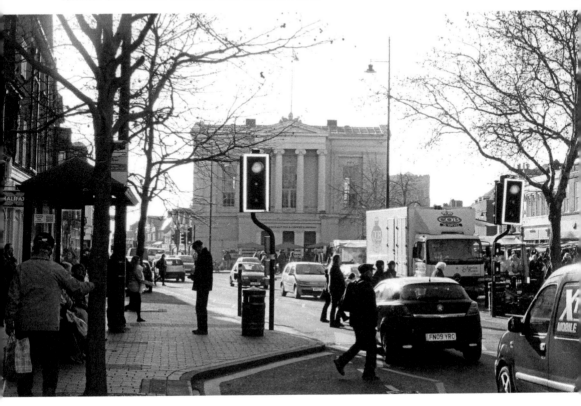

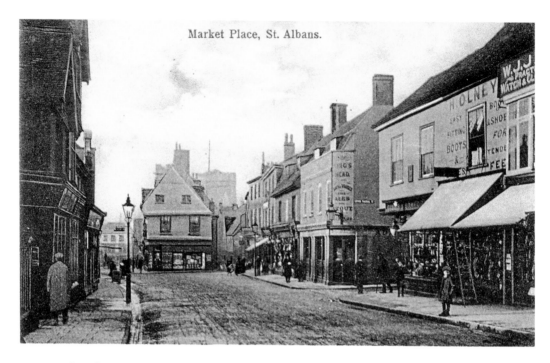

Market Place, St. Albans.

Market Place IV

Southwards of the Market Place lies the High Street with many houses of the seventeenth century, the best being on the south side, with the date 1665 in its gable. The town and abbey were often at loggerheads, and it has been commented that the building of the Clock Tower between 1403 and 1412 directly opposite the Waxhouse Gate entrance to the abbey could be seen as a gesture of defiance towards the abbot and monks. A gate of this name existed in the mid-fourteenth century and it was rebuilt between 1420–40 by Abbot Wheathampstead.

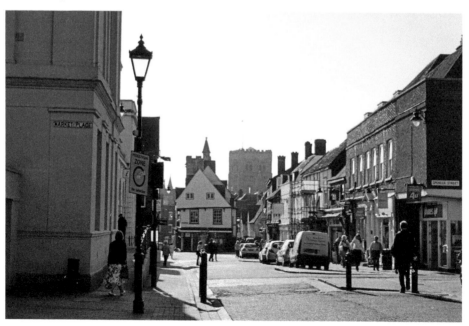

Peahen

The *Victoria County History* of 1908 tells us: 'Before the present London Road was made in 1794 there was no road eastward from St Peter's Street and Holywell Hill (formerly Holywell Street) between Victoria Street and Sopwell Lane, then the London Road. Between these points on the steep hill into the town were the principal inns. Of those that now remain the 'Peahen,' which stands at the south corner of the London Road, is, perhaps, the most important. This dates back to the fifteenth century, but the house has recently been entirely rebuilt in a style which cannot be said to harmonise with its surroundings; the only relic of the old inn is some sixteenth-century woodwork in the coffee room.'

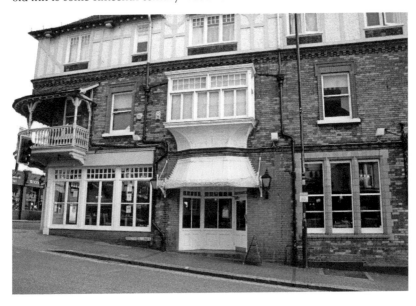

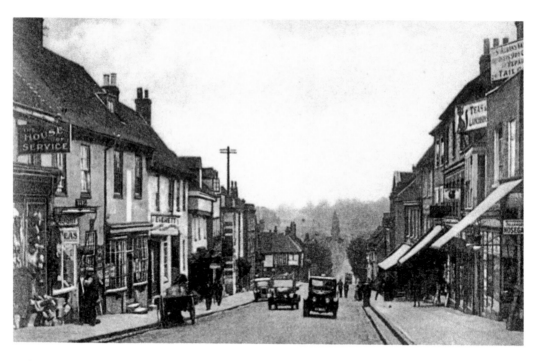

Holywell Hill III

The upper photograph dates from *c.* 1920 and was taken in the immediate vicinity of the Peahen Hotel, looking south down Holywell Hill. The photograph below shows the same view in 2012.

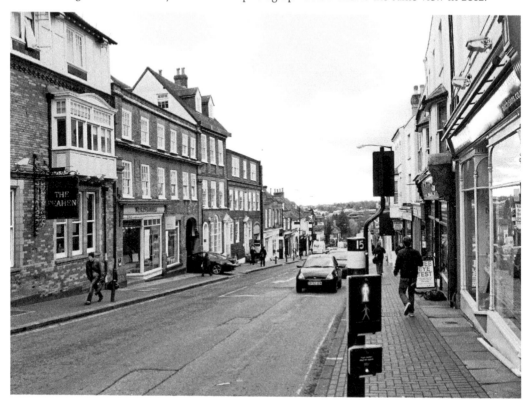

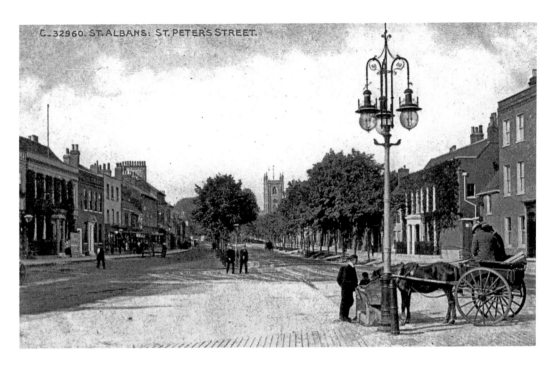

C.32960. ST.ALBANS: ST.PETERS STREET.

St Peter's Street

The postcard dates from *c.* 1905 and looks from south to north with St Peter's Church at the far end. St Peter's Street was in 1245 described as the *magnovico* or 'great street'. The second picture dates from 2012 and shows the first scene as it is today.

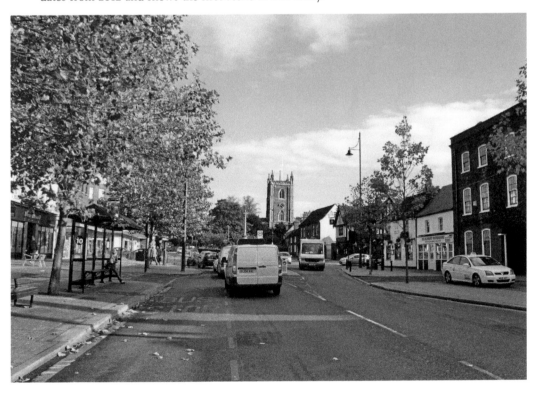

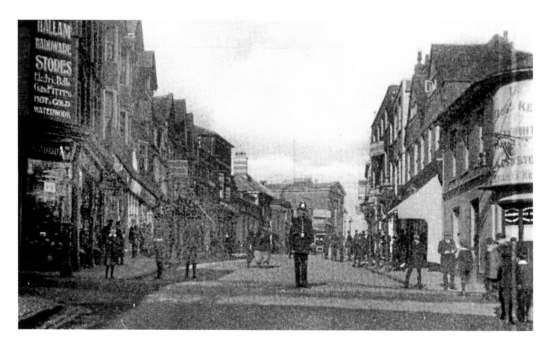

Chequer Street

The first illustration is from the Peahen Crossroads looking north towards the Town Hall. Military police can be seen to the left of the picture, which dates from the period of the First World War. The photograph below shows the busy crossroads in 2012.

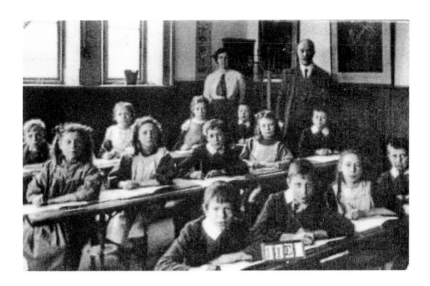

St Michael's

The 1916 class of children at St Michael's, a Church of England Voluntary Aided Primary School, founded in 1811 by the 2nd Earl of Verulam to provide an education for the local poor children. It became a Church School in 1876. The school is situated next to the church opposite the Verulamium Museum.

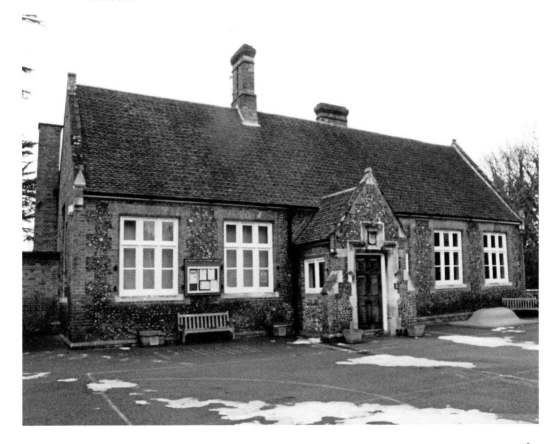

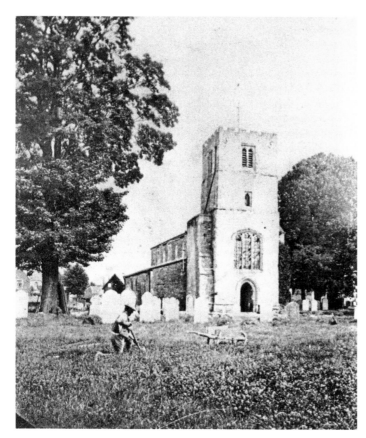

St Michael's Church I
The old photograph depicts St Michael's church before restoration. A gardener can be seen tending the graveyard in this image dating from *c.* 1880. The modern 2012 photograph illustrates just how extensive the renovations to the church were.

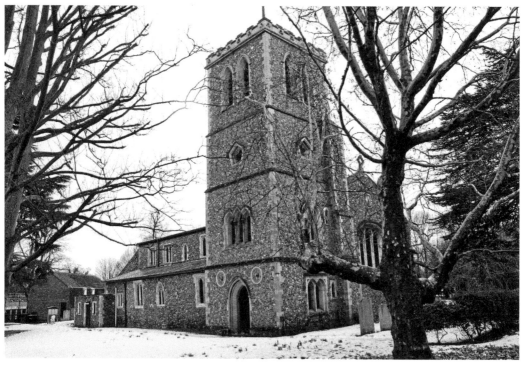

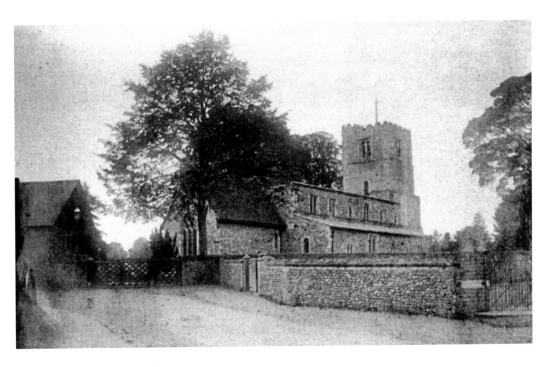

St Michael's Church II
The old picture dates to before the restoration of St Michael's church. The present tower dates from 1896. The church was originally built in the year 948 by Abbot Wulsin who was also responsible for the churches of St Peter and St Stephen. The church contains some interesting monuments.

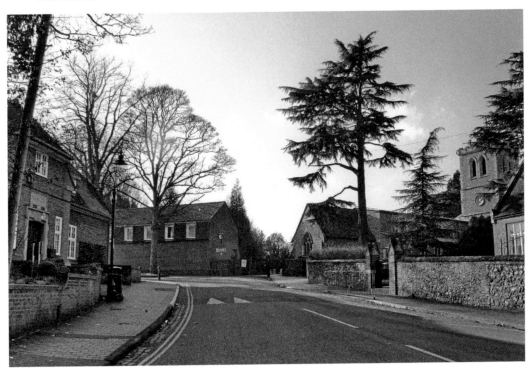

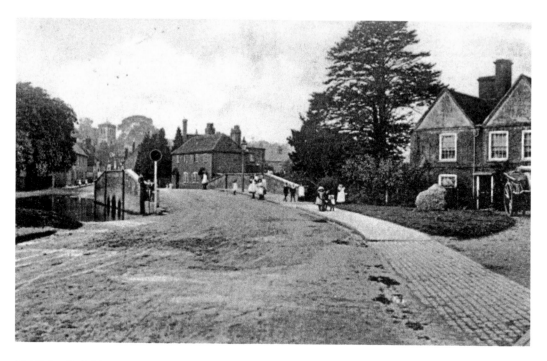

St Michael's Bridge I

Above is a picture of St Michael's Bridge and Kingsbury Mill. The bridge was built in 1765 at a cost of £280. There was an earlier bridge or bridges as they were mentioned in relation to the Second Battle of St Albans in 1461 'Pons de la Maltemyll'. The Mill is now a restaurant and museum. It was mentioned by inference in the Domesday Book of 1086. The sepia photograph above dates from *c*. 1905.

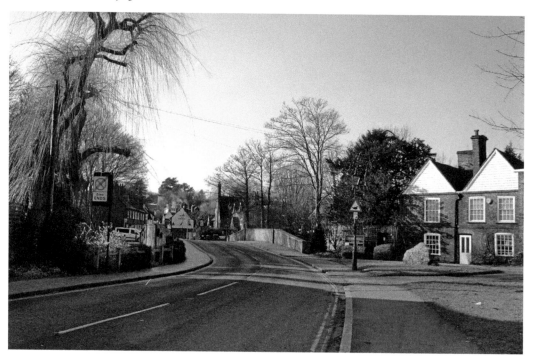

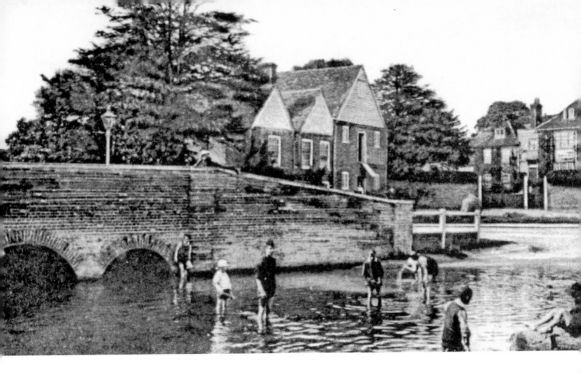

St Michael's Bridge II

The old picture dates from *c.* 1910, and again shows St Michael's Bridge, with children paddling in the River Ver. In the background are the Kingsbury Mill, and on the right, Kingsbury Manor House. The modern picture, 2012, shows how little this area has changed.

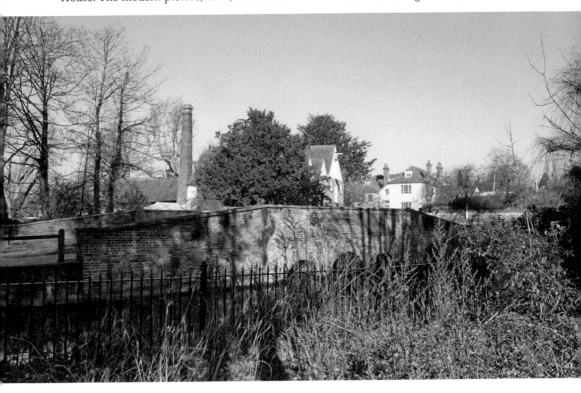

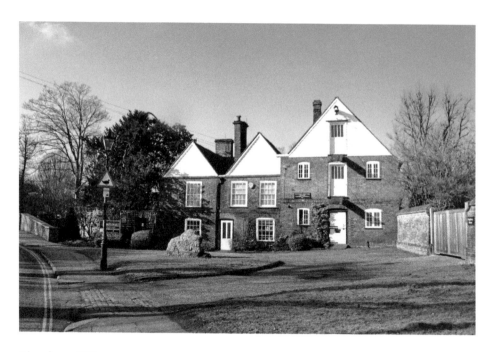

Kingsbury Mill

Kingsbury Mill is situated on the corner of St Michael's Bridge at the bottom of Fishpool Street. It was formerly the site of the Abbot's Malt Mill. It was documented, if vaguely, in the Domesday Book of 1086 but was certainly in existence by 1194. The mill was referred to in 1658 as St Michael's Mills. The current building known as Kingsbury Mill was built in the sixteenth century. The mill was modernised in the nineteenth century and functioned until 1960. In 1973 it was turned into a working museum. It now also boasts a waffle house. The lump of stone in front of the mill is a piece of Hertfordshire Puddingstone which is (almost) native to Hertfordshire.

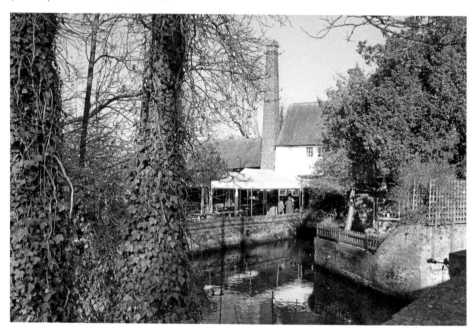

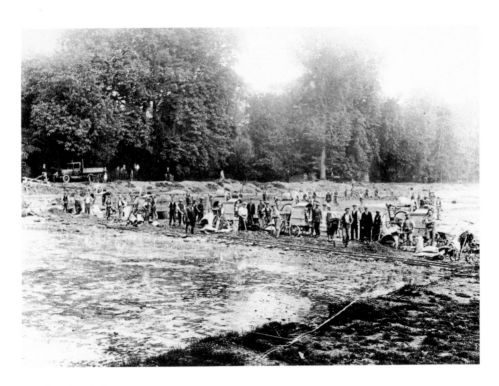

Verulamium Lake

The photograph shows men at work digging Verulamium Lake around 1930. Verulamium Park is so-called because it occupies part of the site of the Roman city of Verulamium. The land was bought in 1929 by the city council from the Earl of Verulam; it had formerly been St Germain's Farm, part of the Verulam estate. The digging of the ornamental lake provided work for many unemployed men during the depression, thanks to government grants to fund its construction. The 2012 photograph shows how impressive the result was.

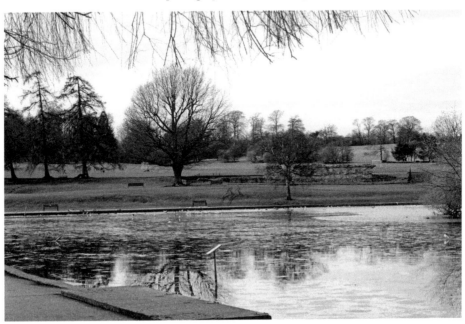

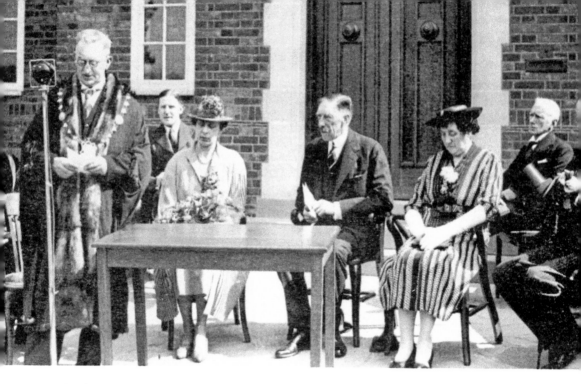

Verulamium Museum I

The museum opened on 8 May 1939. In the photograph are the mayor, welcoming the Earl of Harewood and the official party who are from left, the town clerk, Princess Mary, the Earl of Harewood and the mayoress.

Verulamium Museum II

The Verulamium Museum has been completely modernised and houses the original Wheeler finds from the 1930s excavations as well as a major collection of Roman artefacts including some of the finest mosaics in the country. Included in the displays are the remains of a burial of a local king unearthed in Folly Lane in 1992 which included the remains of enamelled horse equipment, a chariot and iron mail armour. Also on display are several iron plates from a legionary's body armour which were found in a pit outside the town. The museum stands in the middle of the site of the Roman city of Verulamium. The second illustration dates from shortly after the original museum was opened and shows a reconstructed mosaic.

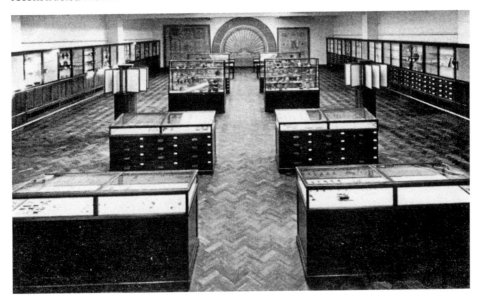

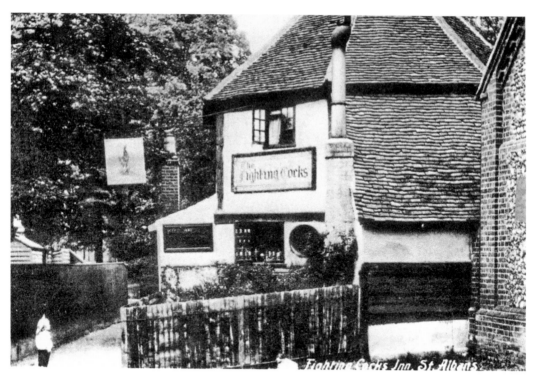

Ye Olde Fighting Cocks

The first photograph dates from *c.* 1886. The hexagonal building was moved from the Abbey grounds to its present position in around 1600. The lower photograph was taken in 2012.

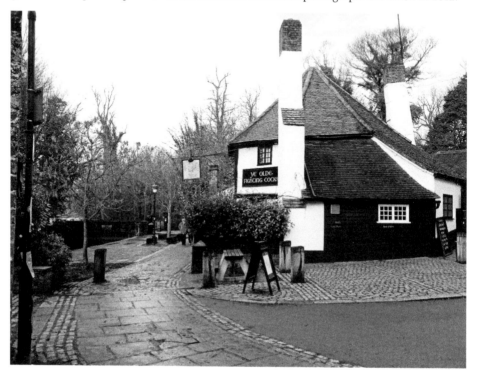

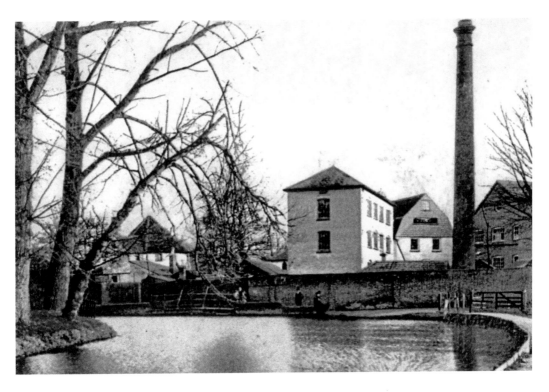

The Silk Mills

Now replaced by modern dwellings opposite the Ye Olde Fighting Cocks inn, Verulam Park, were the Abbey Mills. The mills were converted to make silk in 1804 before which they ground corn. The old illustration above dates from *c.* 1910. In the 1880s, the mill employed 'over 300 hands'. The silk mills were closed in the 1930s, and demolished in the 1950s. The 2012 photograph shows some of the former mills, now modern residences.

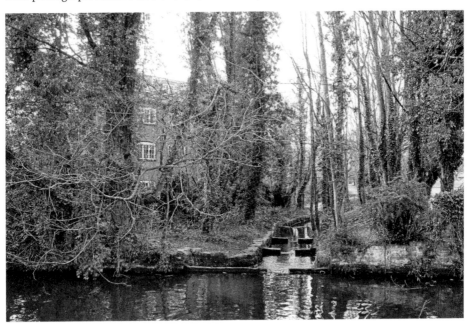

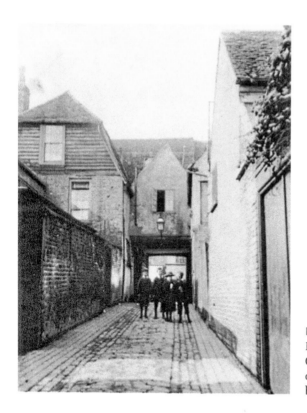

Half Moon Yard

Half Moon Yard stands behind 12 to 14 Chequer Street. The upper photograph dates from 1899, and the watercolour by A. S. Phipson is dated 1902.

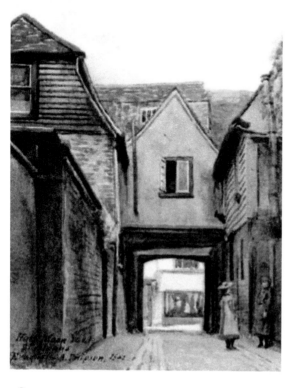

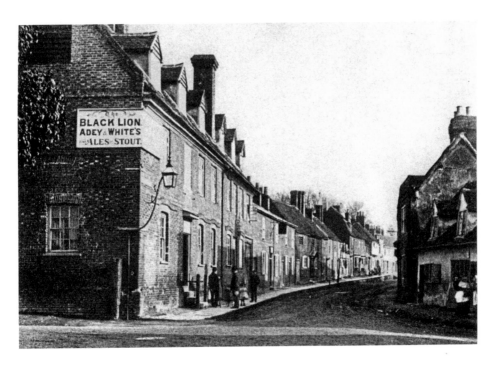

Fishpool Street

The 1908 *Victoria County History* tells us: 'Westward of Romeland is Fishpool Street, which from entries in the *GestaAbbatum* appears to have existed under the same name before the Conquest. There are many examples in it of seventeenth-century pargeted houses, notably Godmersham House on the south side, and further on the same side the dairy house of St Michael's Manor, which was formerly the Angel Inn. The lower part of Fishpool Street was known as Sally Path.' The two photographs are 110 years apart. Fishpool Street was one of the poorest areas of St Albans at the turn of the twentieth century.

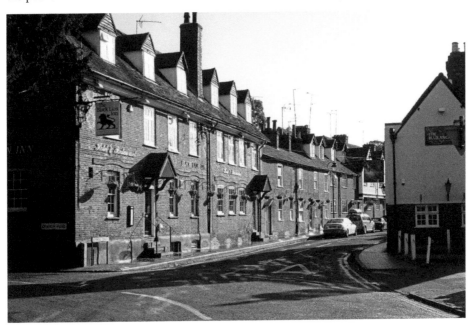

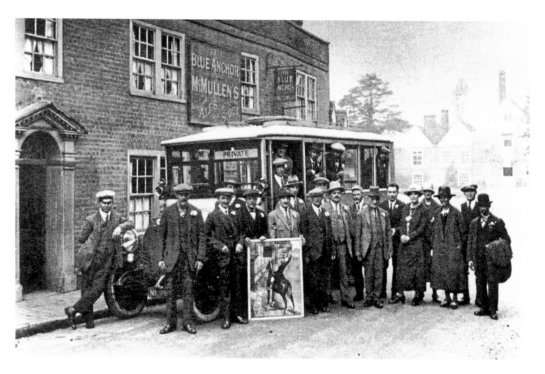

The Blue Anchor

The Blue Anchor is situated at the bottom of Fishpool Street. The picture, dating from the 1920s, depicts an outing. The figures are holding an advertisement for Benskins Brewery, the owners of the pub. In the background can be seen Kingsbury Mill.

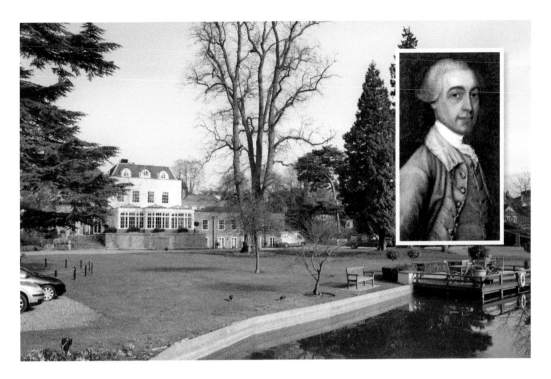

St Michael's Manor

St Michael's Manor on Fishpool Street was built by the Gape family, a prominent St Albans family in 1668. Inset is a portrait showing Joseph Gape, *c.* 1760. Below is a watercolour of the River Ver at the back of St Michael's Manor from the latter part of the nineteenth century.

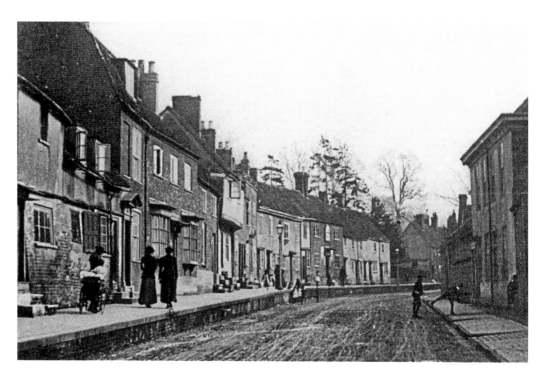

Fishpool Street Curve

The old photograph dates from around 1910 and shows the curve in Fishpool Street. The lower part of Fishpool Street as far as St Michael's Manor was originally a Roman road. William Grindcobbe, one of the local leaders in the Peasants' Revolt in 1381, lived in a cottage along here known as Coppydhall, which was described as 'ruinous and in decay' in 1538.

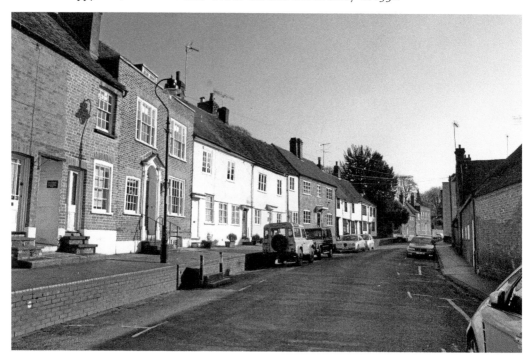

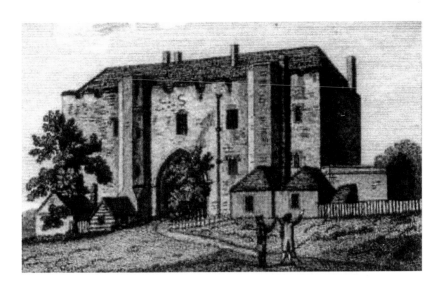

The Abbey Gateway

The upper illustration dates from 1787. The Abbey Gateway is the only building that remains of the monastery buildings of the Abbey of St Albans. Built in 1365, it was used for many years as a prison. It ceased to be the town gaol in 1867 when a purpose-built prison was built on Grimston Road, near the station. It now forms part of St Albans School. In the Gatehouse Prison, offenders were given bread but there was no heating. Passing strangers often heard a pleading voice from within begging them to put alms into an old shoe, which the prisoners let down by string from a window, to enable them to have a fire. Apparently prisoners could escape from the prison by climbing out of a window and jumping on to a tree. The modern photograph shows the prison that replaced the Gatehouse in Grimston Road. The BBC used the main gate in the opening shots as 'Slade Prison' in the title sequence of the TV series *Porridge*, starring Ronnie Barker.

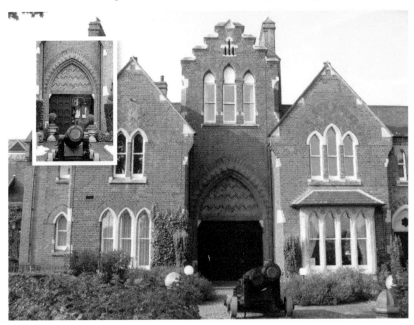

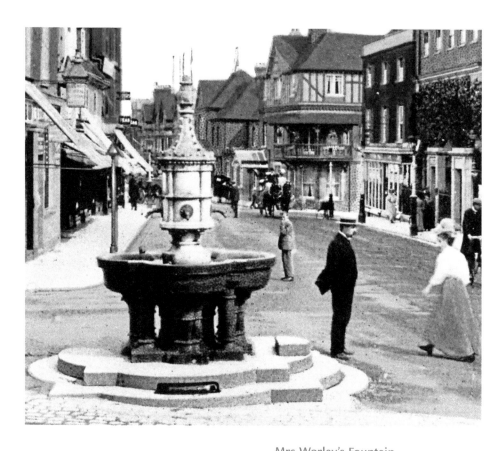

Mrs Worley's Fountain

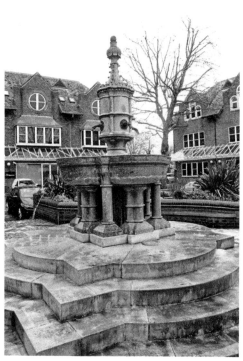

Mrs Worley's fountain is situated behind the Old Prison (now the Registry Office) on Grimston Road, St Albans. This fountain was designed by the architect George Gilbert Scott. Mrs Worley was a wealthy widow who gave this drinking fountain to the town in the 1870s. Originally, it was situated in front of St Albans Clock Tower on High Street. However, as traffic increased it became too obstructive and was moved in the 1920s. It was found on a council tip and was relocated here. The second picture is a detail from a 1905 illustration showing the fountain in its original location.

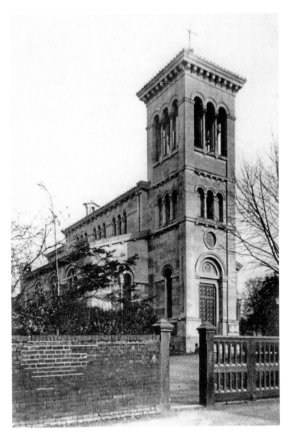

Christ Church

Christ Church was begun as a Catholic Church by the MP Raphael before his sudden death in 1848. It remained unfinished until Mrs Worley completed it as a private chapel. It is now converted into offices. The illustration below shows the building in 2012.

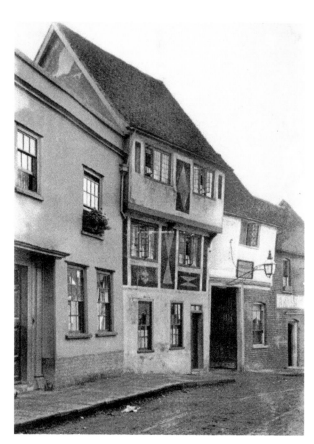

Fishpool Street
In the centre of the old photograph is 13 Fishpool Street and on the right is the entry to the Crow public house.

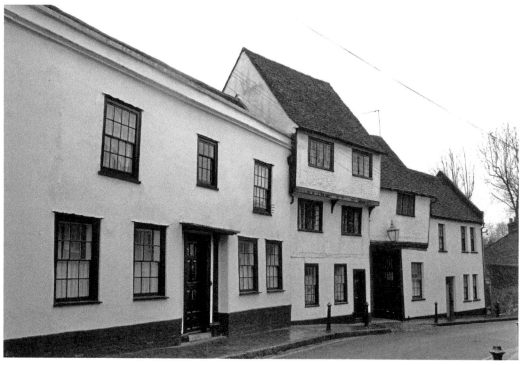

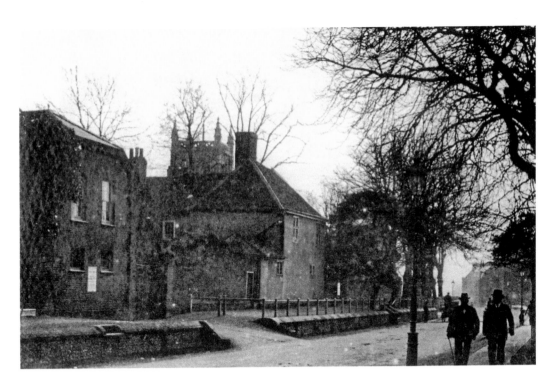

Hall Place

Hall Place, demolished in around 1905, was described in the 1908 *Victoria County History*: 'Immediately north of St Peter's Church stood until a year or two ago Hall Place, a picturesque old house in which, or its predecessor, Henry VI is said to have slept on the night before the Battle of St Albans. The site and grounds of the house have now been laid out in roads and are being built over, and nothing remains but the red-brick boundary wall and a pretty wrought-iron gate.' It is unlikely that Henry VI spent the night there.

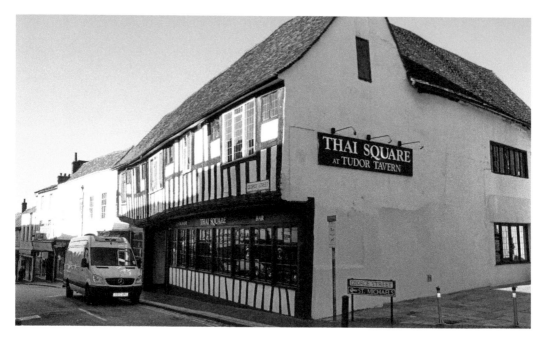

George Street

S. Harvey's Cash Stores, George Street, St Albans. This building was the Tudor Tavern, and in 2012 it is a Thai restaurant. The building suffered a major fire as the Tudor Tavern. The building is a mixture of two fifteenth-century inns, the Swan and part of its neighbour to the west, the George. The oldest part of the building fronting Verulam Road was built around 1400. The George was known to be in existence in 1401. In the early ninteenth century there was a coach service from the George to the Ram Inn at Smithfield in London leaving at 7 a.m. and returning at 2 p.m. in winter and 2.30 p.m. in the summer, except on Sundays. The George Hotel closed in 1933.

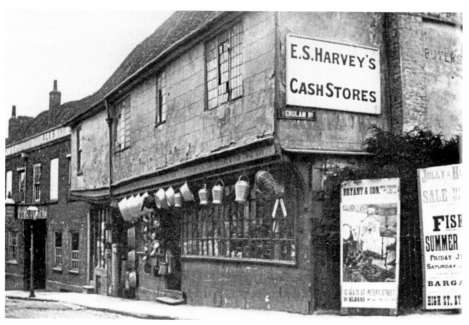

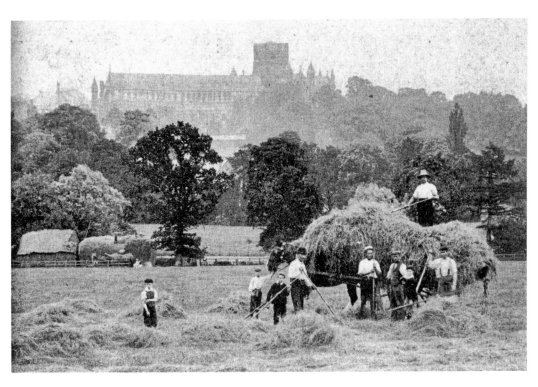

St Germain's

A photograph taken from the former St Germain's farm, *c.* 1905, showing how recently the area relied on farming. The second photograph was taken from Verulamium Park, near the hypocaust, in 2012.

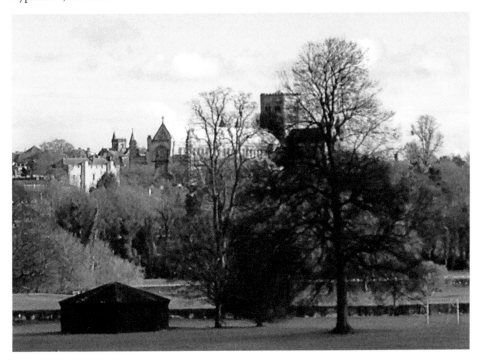

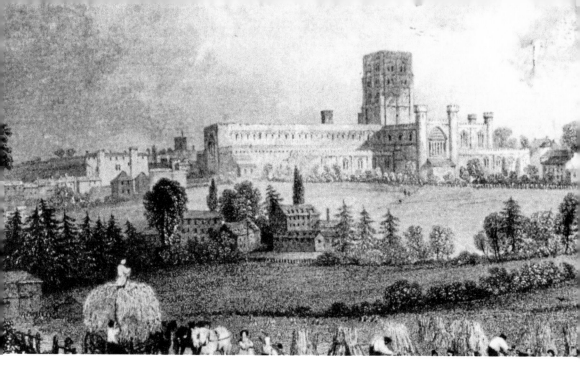

Farming

An engraving from the mid-nineteenth century depicting harvesting from the Verulamium Park area with the Abbey in the background. The photograph below is the same view in 2012.

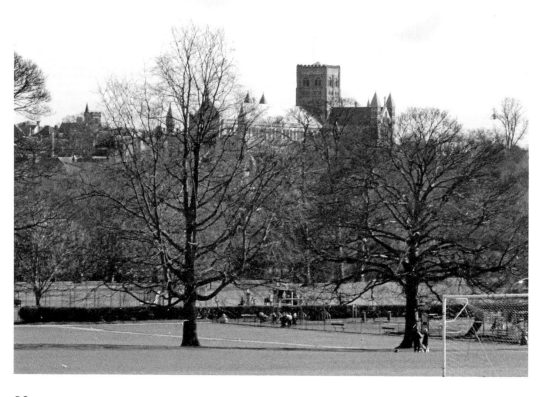

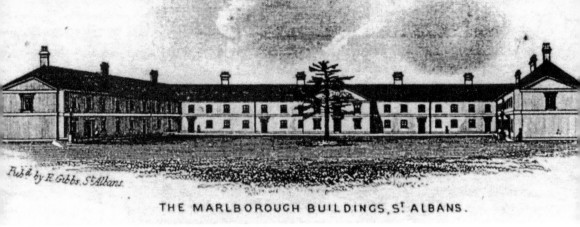

THE MARLBOROUGH BUILDINGS, S.T ALBANS.

Pub.d by E. Gibbs, St Albans.

Marlborough Buildings Almshouses

The Marlborough Buildings almshouses were founded and endowed by Sarah, Duchess of Marlborough, a sometime resident of Holywell Hill, in 1736. They were intended to provide accommodation for '36 decayed men and women'. They stand opposite the St Albans Museum in Hatfield Road.

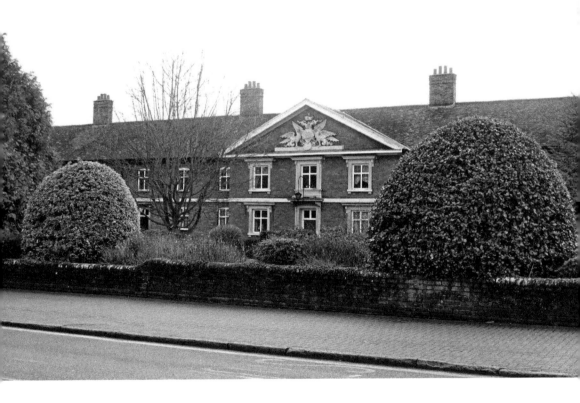

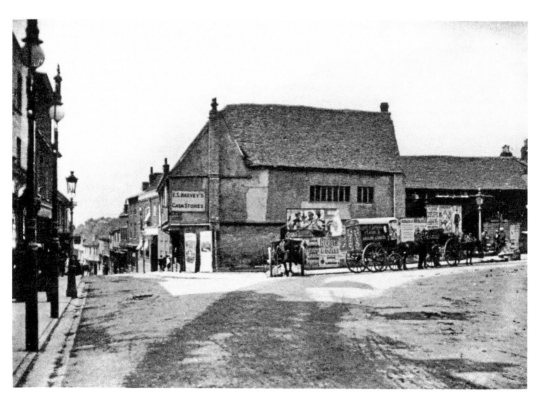

Verulam Road and George Street

The corner of Verulam Road and George Street in 1880 and 1912, with the Clock Tower is to the right.

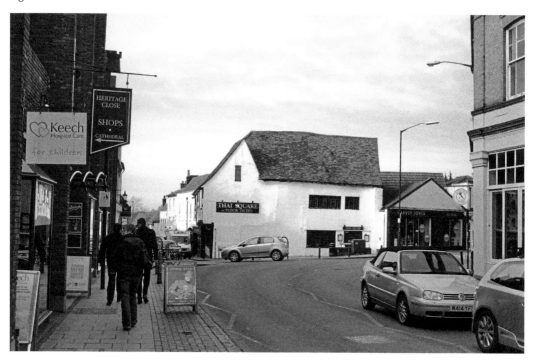

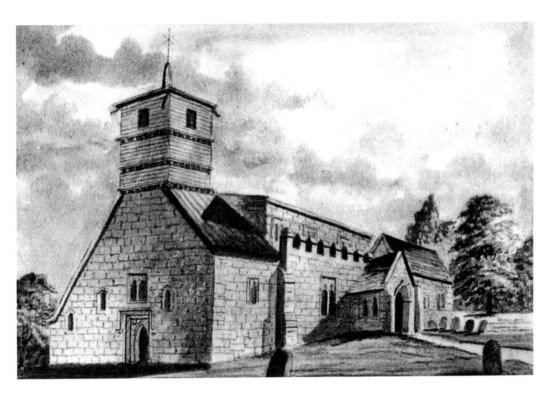

St Stephen's Church

Above, St Stephen's Church in 1824. One of the three built by Abbot Ulsinus. It is situated to the south of St Albans on Watling Street. The original late Saxon building consisted of a nave and chancel to which aisles were added. The church was consecrated between 1101–1118 and probably dates from the tenth century.

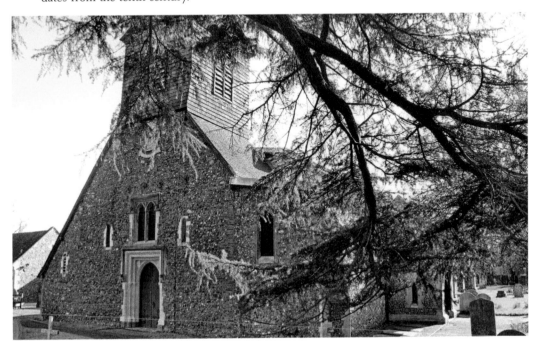

Romeland

The name derives from the term 'roomland' or space. It was here, during the Peasants' Revolt of 1381, that the rebels gathered prior to breaking in to the Abbot's prison in the Great Gate, and this was also where George Tankerfield, on 26 August 1555, was burned at the stake for being a Protestant. He was brought from Newgate to St Albans for execution, and lodged at the Cross Keys Inn. The 1908 *Victoria County History* observes that 'while under confinement at the inn [he] asked for a fire, and pulling up his hose put his leg as near the flame as he could to ascertain how he should endure it on the morrow. The inn was demolished in 1794 to make room for the new London Road.' At the end of the eighteenth century the area was used as a cattle pound. The area was sold to the Abbey for burials in 1835 and was used for this purpose up until 1885.

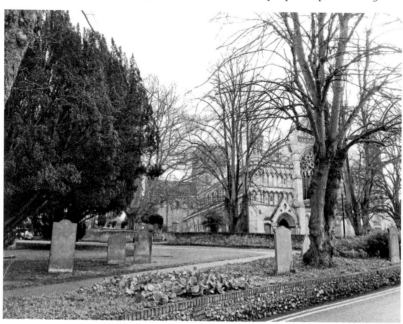

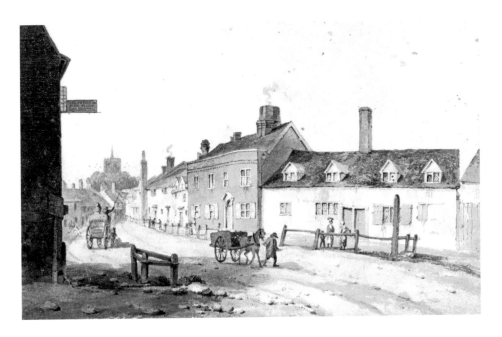

Fishpool Street

A watercolour by G. Shepherd dated 1809. It is of the view looking up Fishpool Street from the junction with Branch Road. A coach painted 'St Albans to London' is driving towards town while a horse and cart is being led by a man in the opposite direction. St Albans Abbey tower can be seen in the distance. The sign on the building on the far left reads 'John Ewington', the name of the landlord of the Black Lion Public House. The building on the opposite side of the road with the ornate door lintel is now the Blue Anchor pub. The cottages on the far right, next door to the Blue Anchor pub, were demolished in 1935. Fishpool Street was one of the main routes into St Albans at this time. The second image shows a similar aspect with the missing cottages, which have been replaced by the Blue Anchor car park.